HUGS

—from—

OBAMA

A Photographic Look Back at the Warmth and Wisdom of

PRESIDENT BARACK OBAMA

EDITED BY M. SWEENEY

CASTLE POINT BOOKS

NEW YORK

www.stmartins.com
www.castlepointbooks.com

The Castle Point Books trademark is owned by Castle Point Publications, LLC.
Castle Point books are published and distributed by St. Martin's Press.

Design by Katie Jennings Campbell

Cover Photo: Scott Olsen / Getty Images News / Getty Images
Interior Photos: United States Government Works / Official White House Photos
by Pete Souza, Lawrence Jackson, and Chuck Kennedy

ISBN 978-1-250-20109-6 (hardcover)
ISBN 978-1-250-20108-9 (e-book)

Our books may be purchased in bulk for promotional, educational, or business use.
Please contact your local bookseller or the Macmillan Corporate and
Premium Sales Department at 1-800-221-7945, extension 5442,
or by e-mail at MacmillanSpecialMarkets@macmillan.com.

First Edition: September 2018

10 9 8 7 6 5 4 3 2

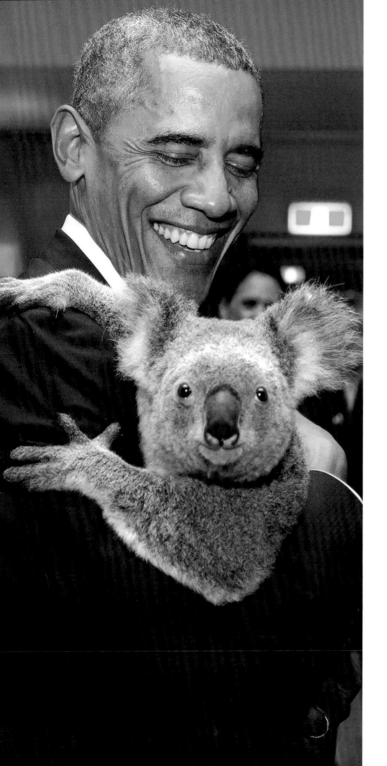

CONTENTS

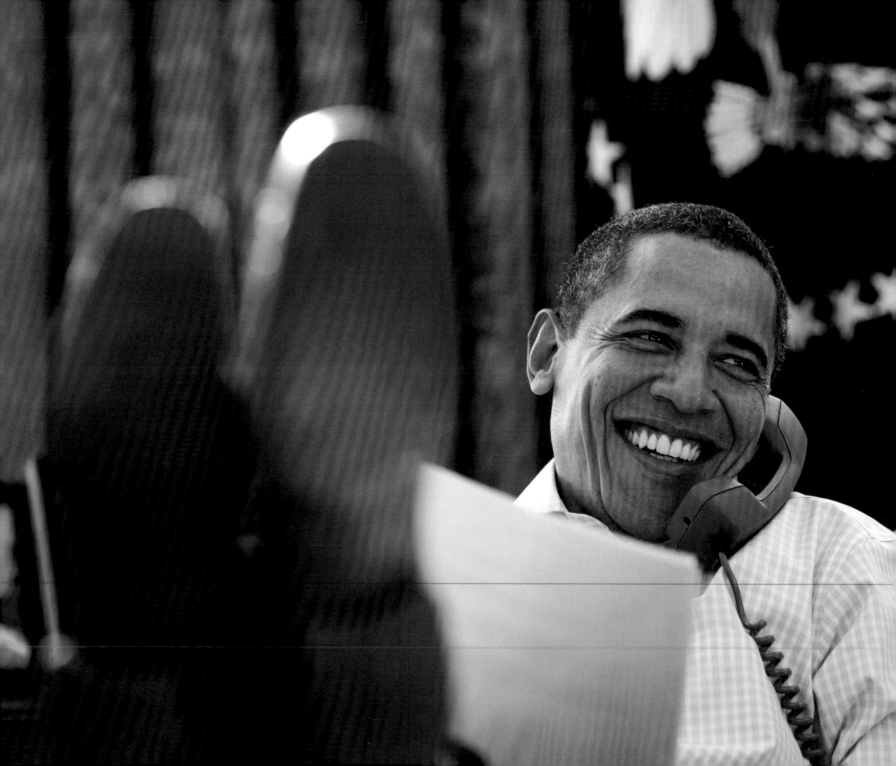

EMBRACING A LEGACY

EVERY COMMANDER-IN-CHIEF LEAVES BEHIND A LEGACY. From policy reform and innovation to economic struggles and international affairs—each presidential term leaves its mark on the American people and the world. Barack Obama, the 44th President of the United States, made history as the first African-American to hold our nation's highest office. He spent eight years championing affordable health care for all, reviving the economy, ending the war in Iraq, fighting terrorism, and building relationships across the globe. He supported equal rights for Americans of all genders, sexual orientations, and races. He inspired growth, innovation, and optimism in the American people.

President Barack Obama's legacy will endure not only because of his accomplishments, but also because of his extraordinary humanity. President Obama's enduring optimism and heartfelt concern for others reflected and renewed our core of American values: love of country, justice for all, and hope for the future. *Hugs from Obama* pays photographic tribute to his compassion and warmth. Each page is a front-row seat to the most moving moments of his historic presidency. Find comfort and assurance in the warmth of President Obama's sincerity, his open-arms approach to others, and the kind, honorable example he set for all Americans.

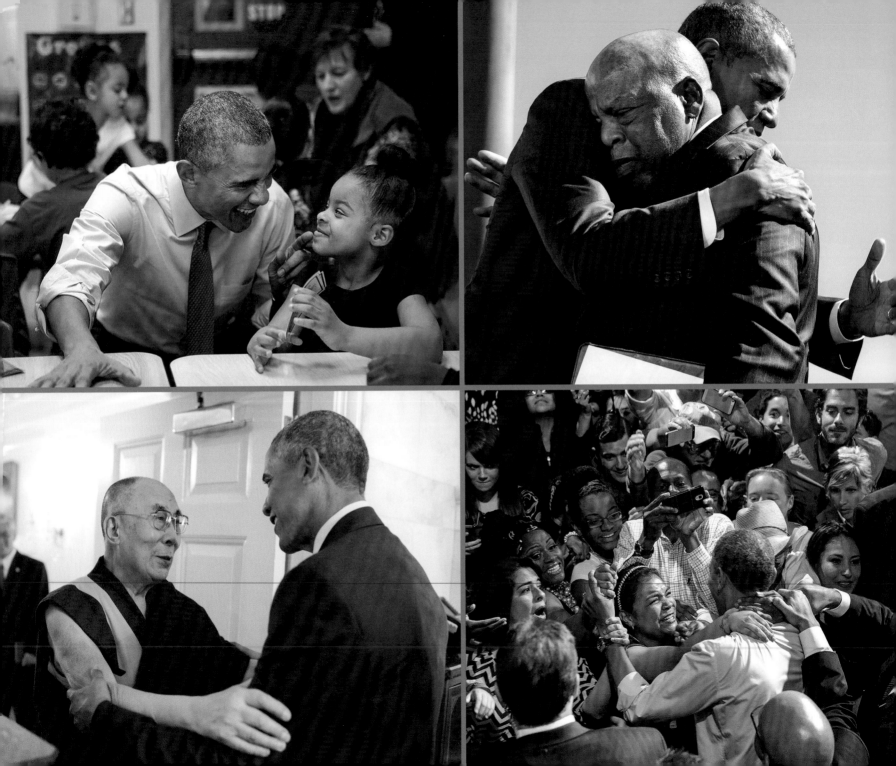

LEADERSHIP

> "WHAT WASHINGTON NEEDS IS **ADULT SUPERVISION**."

—White House Correspondents' Dinner, April 2015

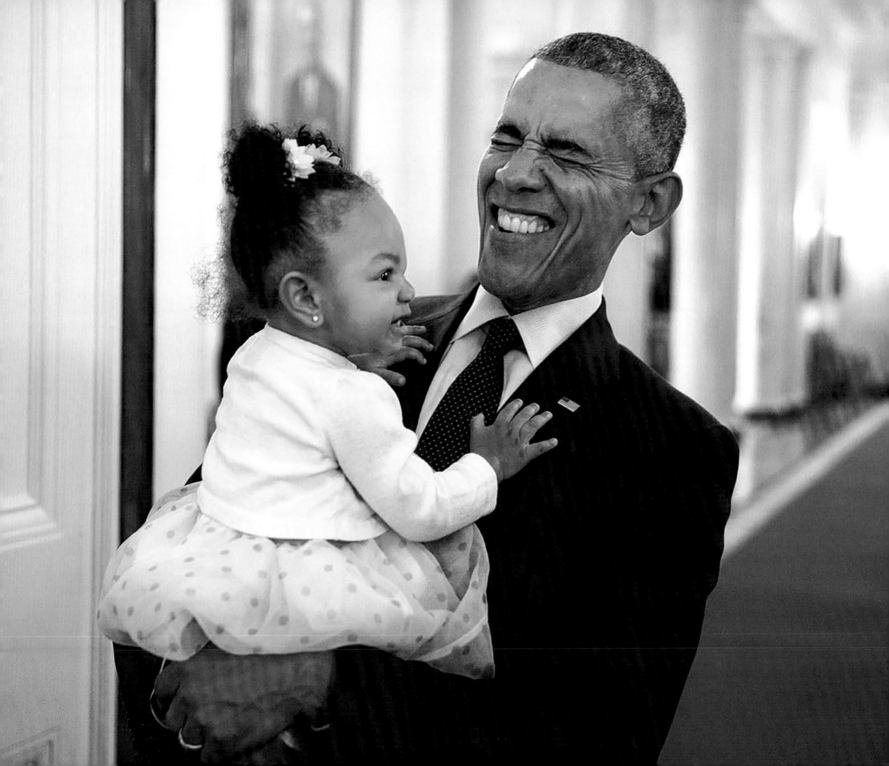

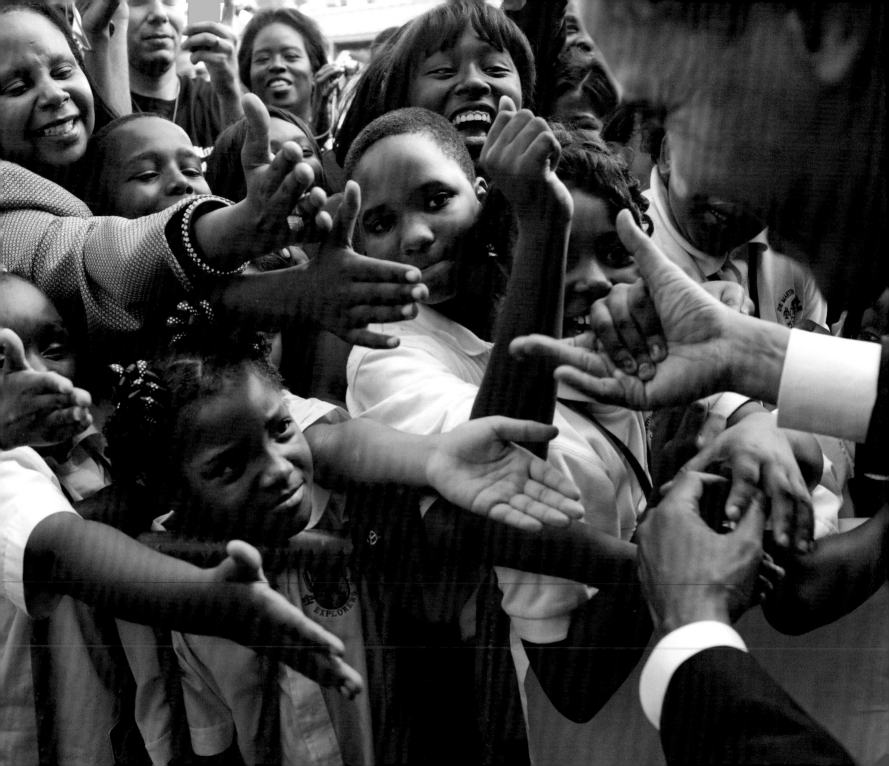

> "We did not come to fear the future. **WE CAME HERE TO SHAPE IT.**"

—Health care speech to Congress, September 9, 2009

" You can't give up your passion
if things don't work right away.

YOU CAN'T LOSE HEART,

or grow cynical if there are twists
and turns on your journey.
The cynics may be the loudest voices —
but I promise you,
they will accomplish the least. "

—Ohio State University commencement speech, May 5, 2013

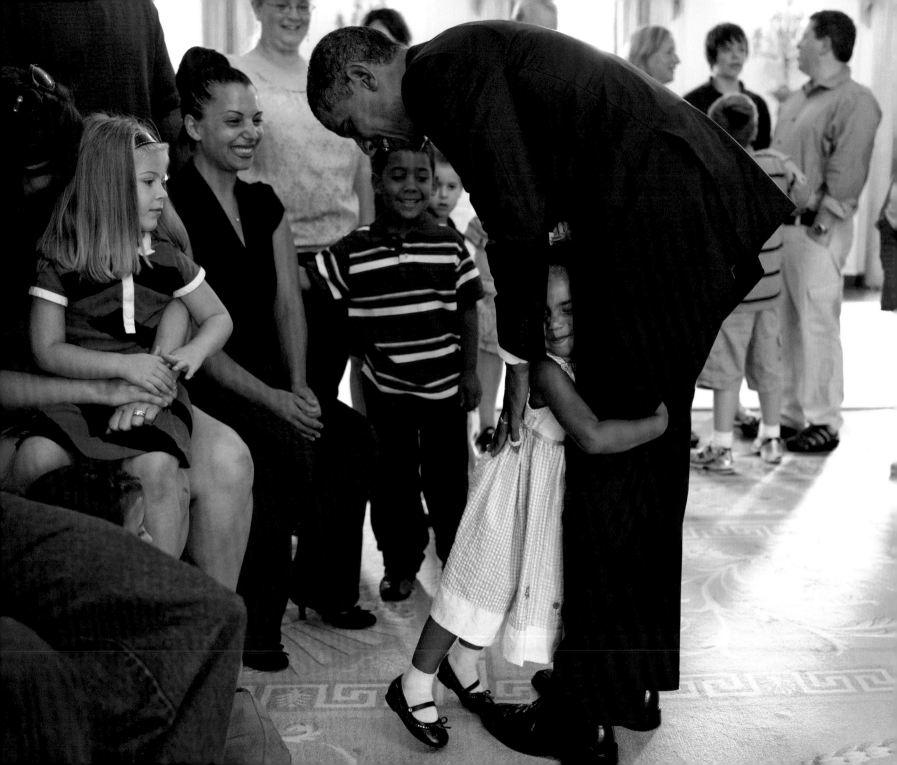

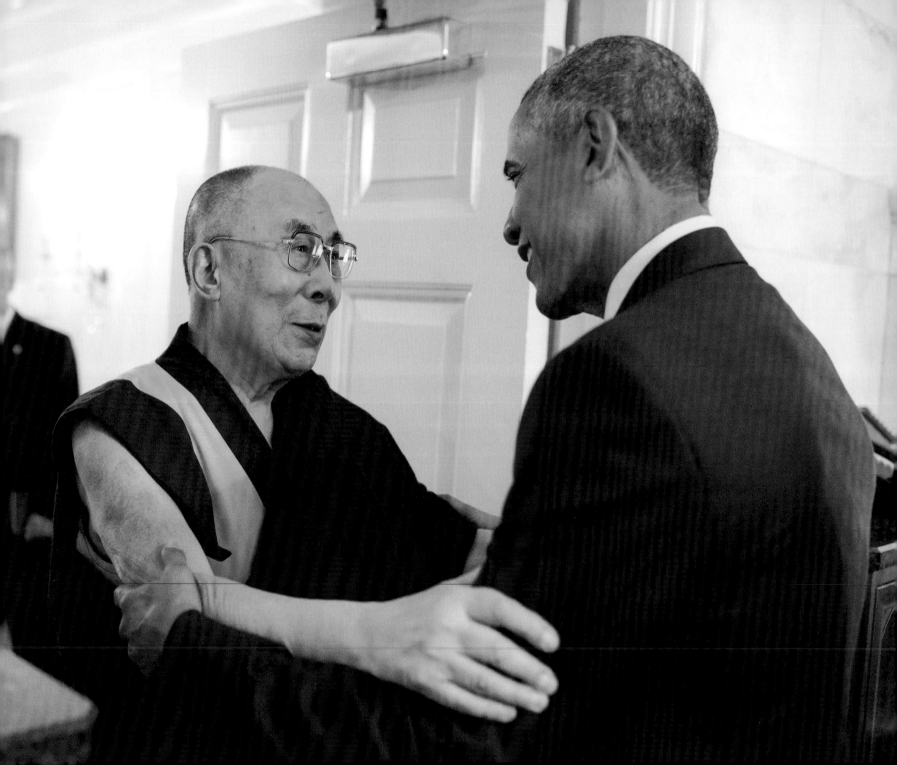

> # "I DON'T GET **TOO HIGH,** DON'T GET **TOO LOW.**"

—Interview with *HuffPost*, March 21, 2015

"DON'T BOO, VOTE."

—Democratic National Convention speech, July 27, 2016

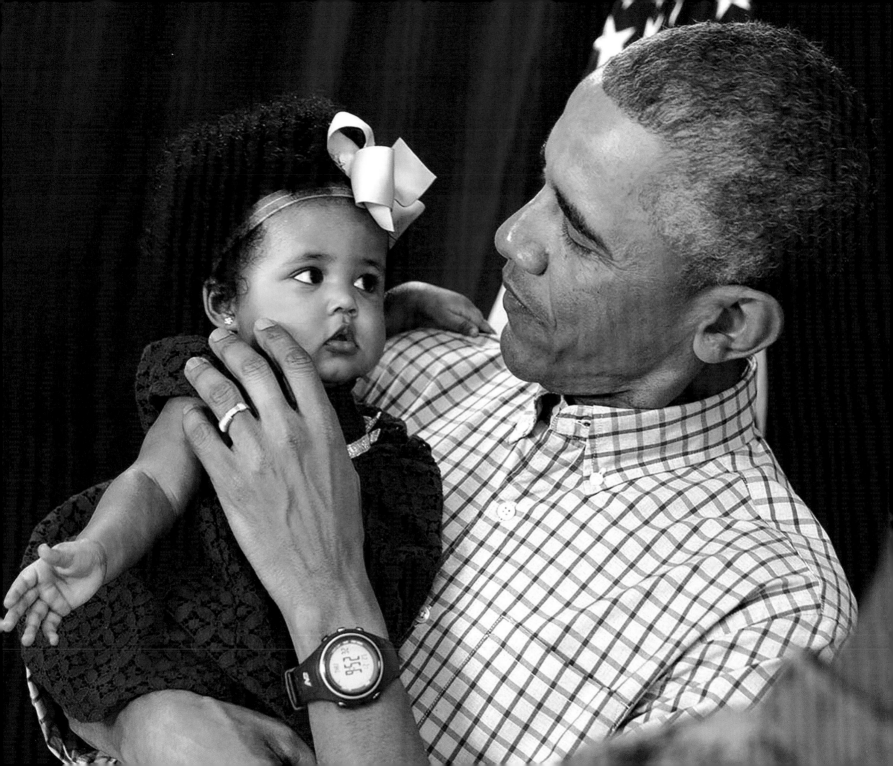

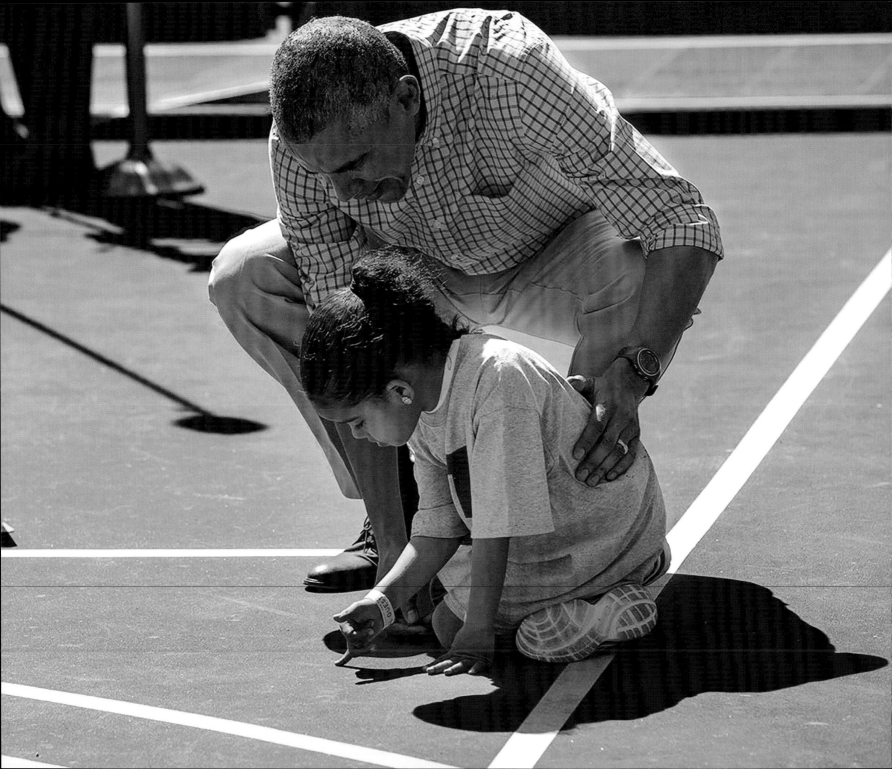

"You can't let your failures define you—**YOU HAVE TO LET THEM TEACH YOU.**"

—Wakefield High School back-to-school speech, September 8, 2009

" That's who we are as Americans. . . .
We ask for nothing more than
the chance to blaze our own trail.
**AND YET EACH OF US IS
ONLY HERE BECAUSE
SOMEBODY, SOMEWHERE,
HELPED US FIND OUR PATH.** "

—Lake Area Technical Institute commencement speech, May 19, 2015

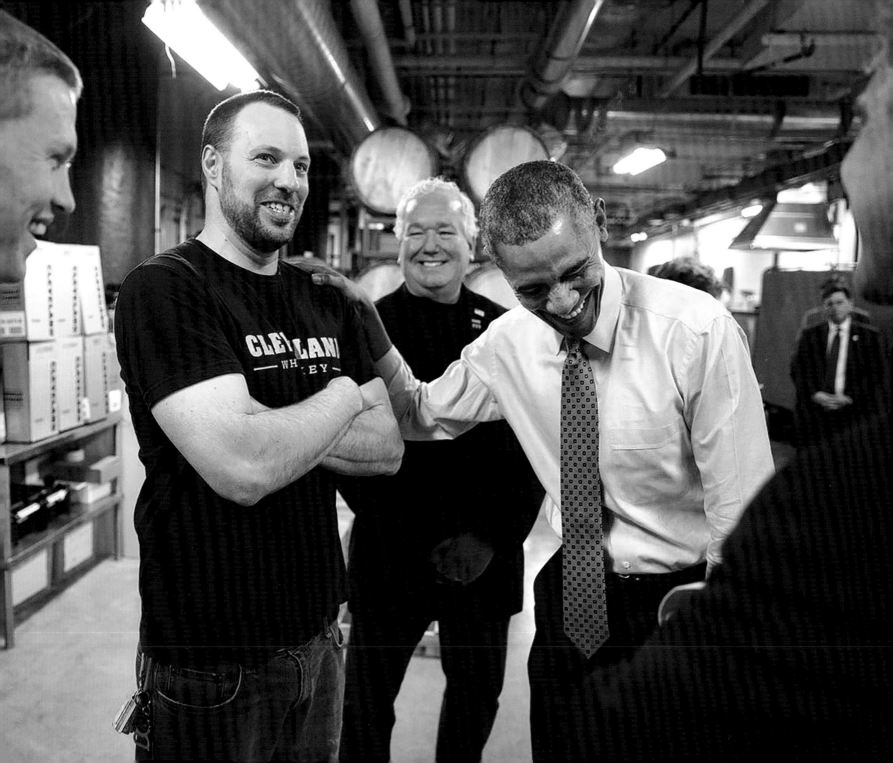

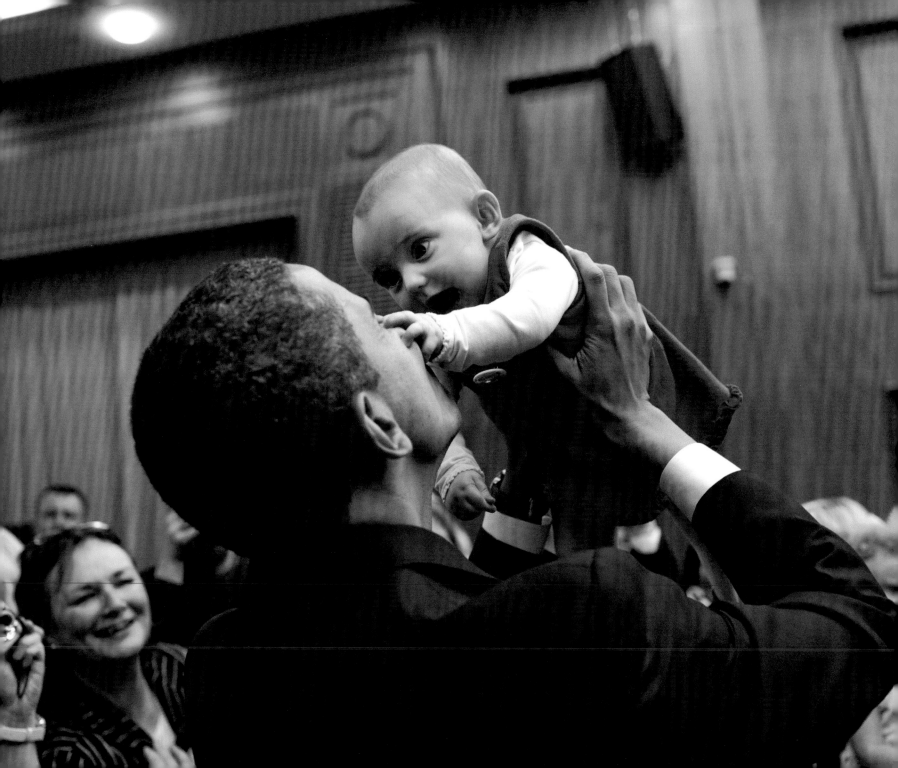

> " Making your mark
> on the world is hard.
> If it were easy,
> **EVERYBODY**
> would do it. "

—Campus Progress Annual Conference, July 12, 2006

" So regardless of the station we occupy,

WE HAVE TO TRY HARDER.

We all have to start with the premise that each of our fellow citizens loves this country just as much as we do; that they value hard work and family like we do; that their children are just as curious and hopeful and worthy of love as our own. "

—Farewell address, January 10, 2017

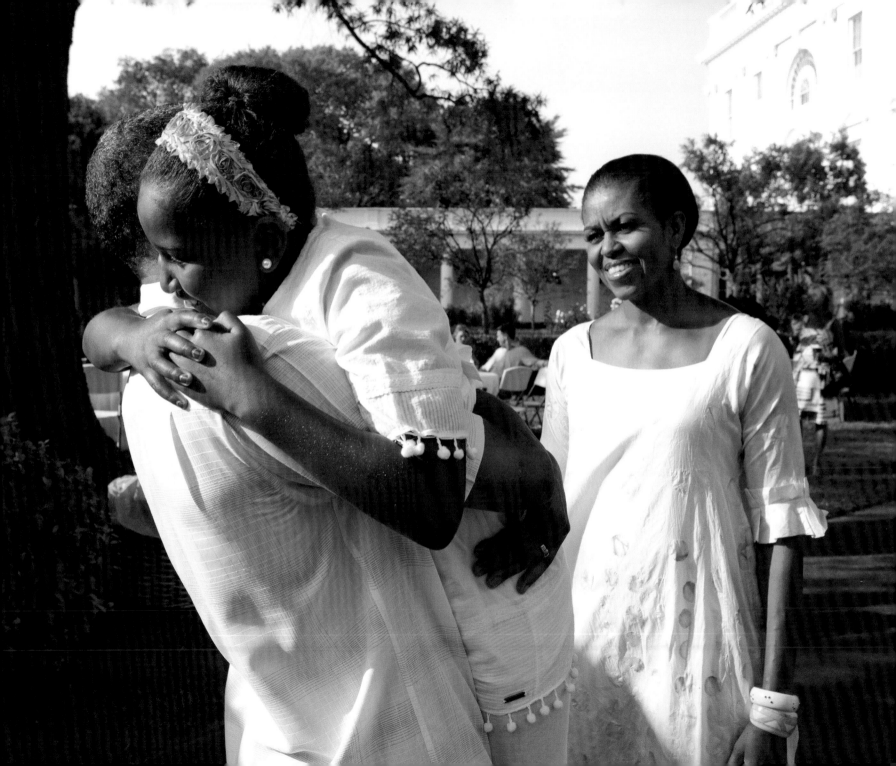

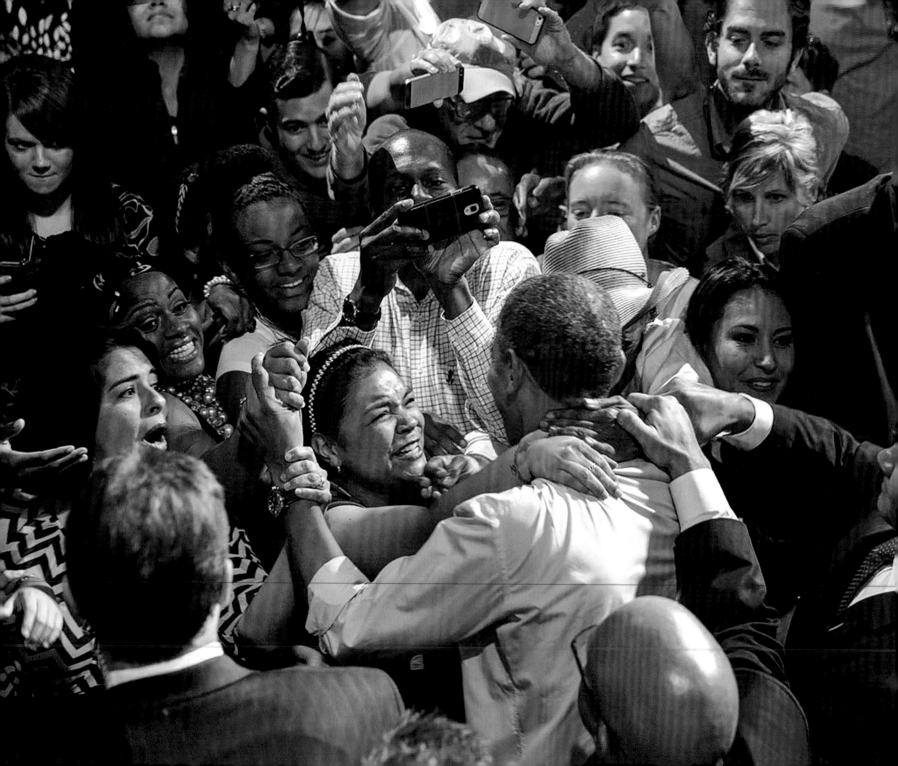

> "…When I ran in 2008, I, in fact, did not say I would fix it; I said **WE COULD FIX IT**. I didn't say, 'Yes, I can.' I said—what? … **'YES, WE CAN.'**"

—Remarks in Santa Monica, California, June 18, 2015

"THAT'S WHAT YOU DID.
YOU WERE THE CHANGE.
You answered people's hopes,
and because of you,
by almost every measure,

AMERICA IS A BETTER,
STRONGER PLACE
than it was when we started. "

—Farewell address, January 10, 2017

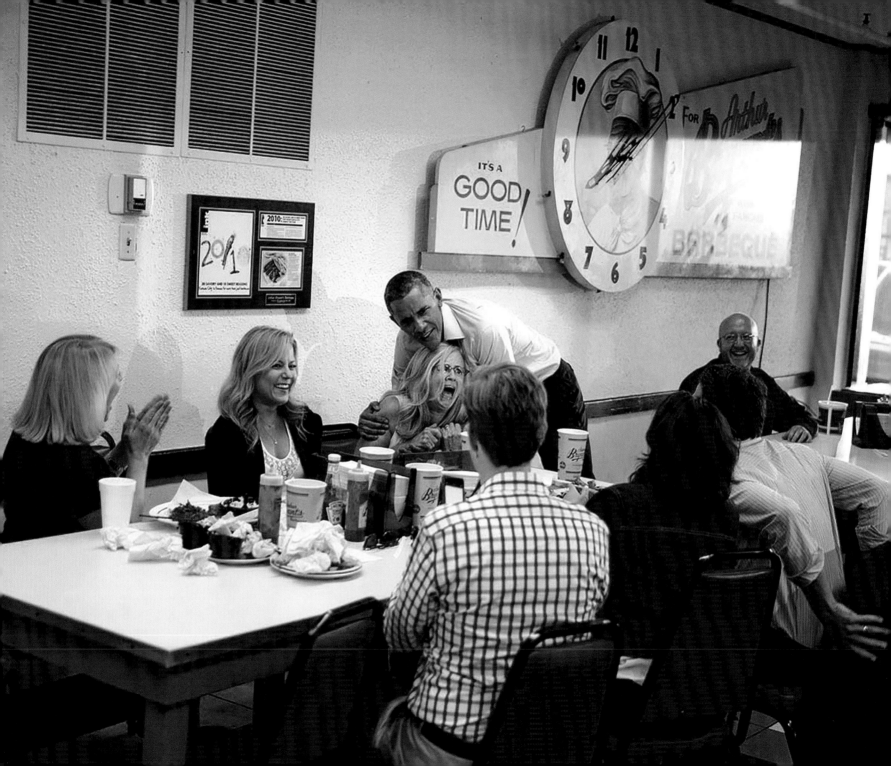

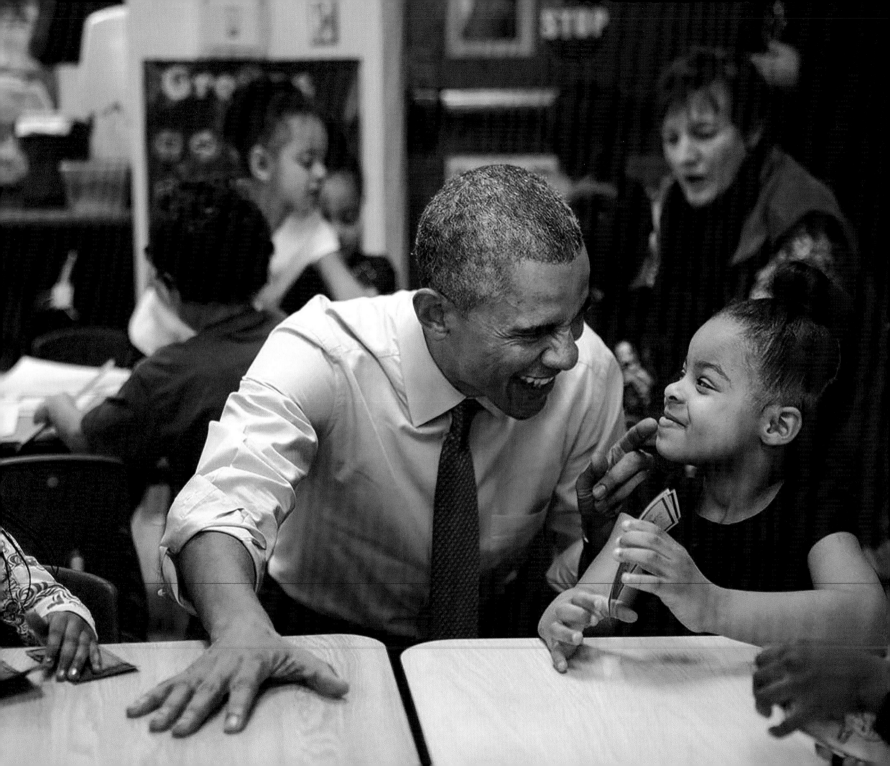

" Our Constitution is a remarkable, beautiful gift. But it's really just a piece of parchment. It has no power on its own.

WE, THE PEOPLE, GIVE IT POWER—

with our participation, and the choices we make. "

—Farewell address, January 10, 2017

" IT FALLS TO EACH OF US

to be those anxious, jealous guardians
of our democracy; to embrace the joyous task
we've been given to continually try to
improve this great nation of ours.
Because for all our outward differences,

WE ALL SHARE THE SAME PROUD TITLE: CITIZEN. "

—Farewell address, January 10, 2017

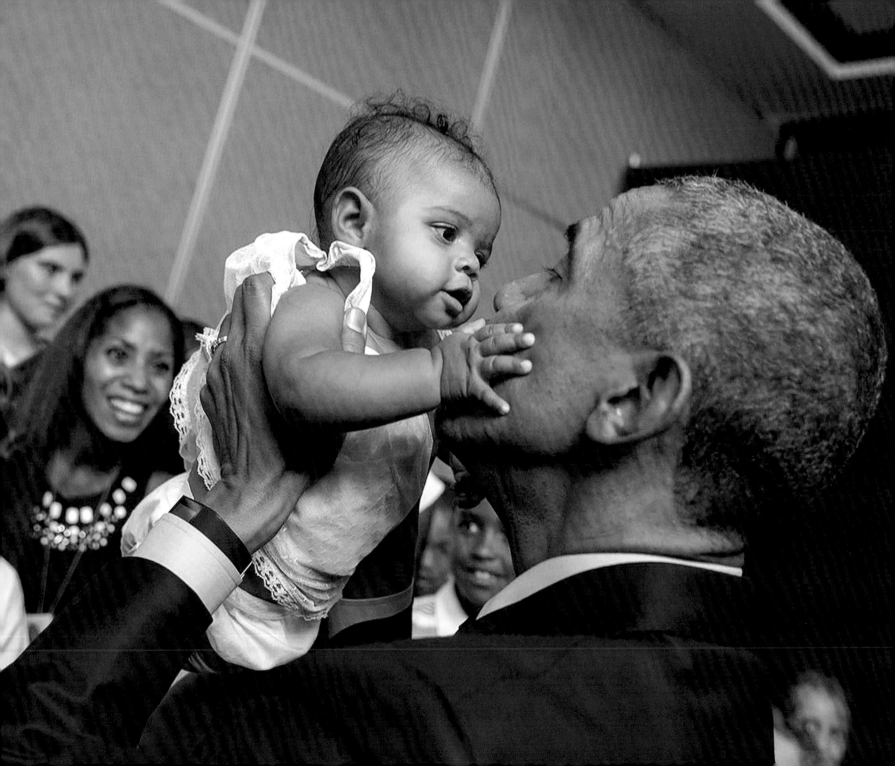

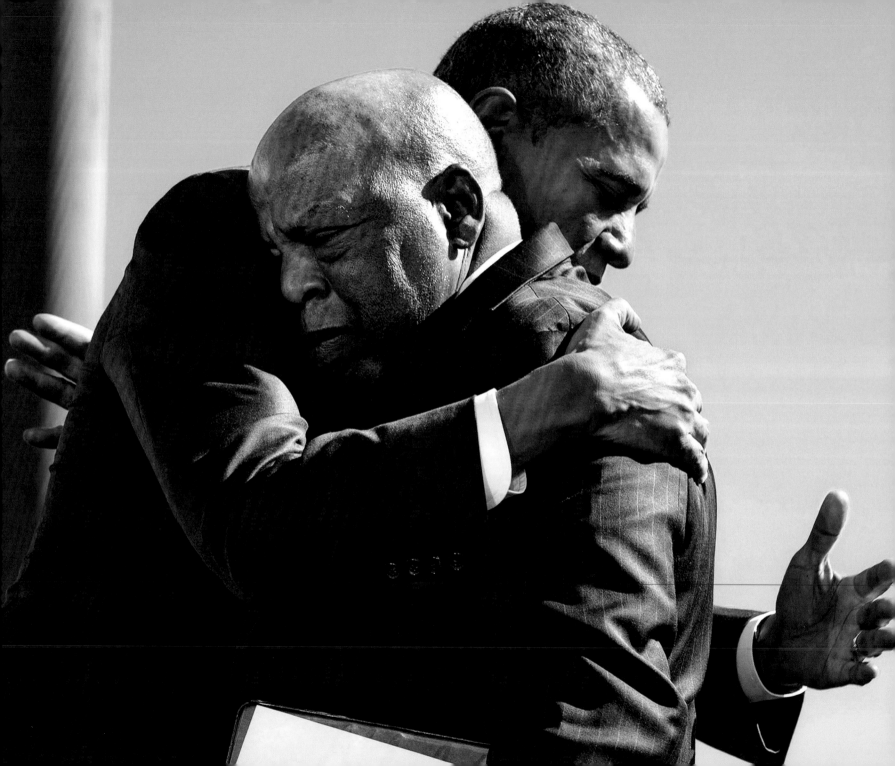

"THE ARC OF THE UNIVERSE MAY BEND TOWARD JUSTICE, **BUT IT DOESN'T BEND ON ITS OWN."**

—50th anniversary of the March on Washington, August 28, 2013

> "If something needs fixing, lace up your shoes and do some organizing. If you're disappointed by your elected officials, grab a clipboard, get some signatures, and run for office yourself.

SHOW UP. DIVE IN. PERSEVERE. "

—Farewell address, January 10, 2017

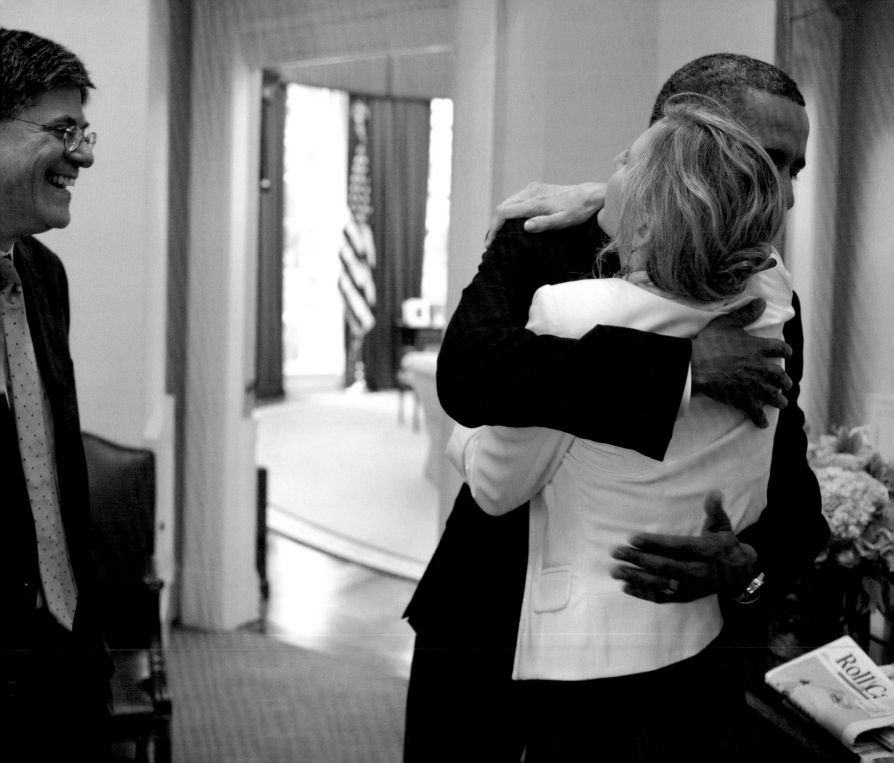

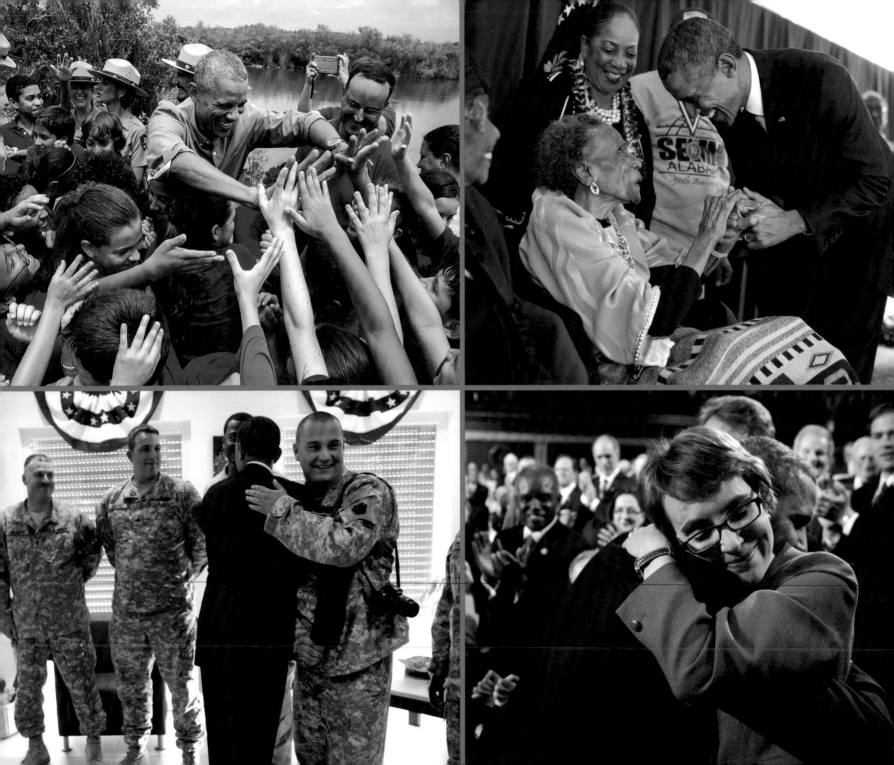

UNITY

"There's not a liberal America and a conservative America—there's the

UNITED STATES OF AMERICA."

—Democratic National Convention keynote address, July 2004

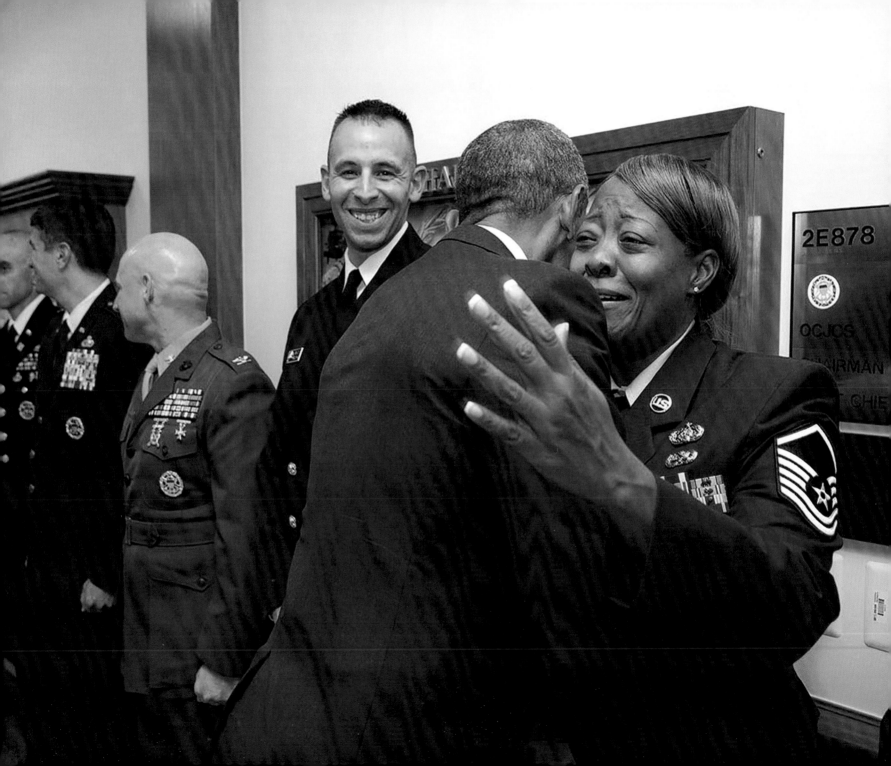

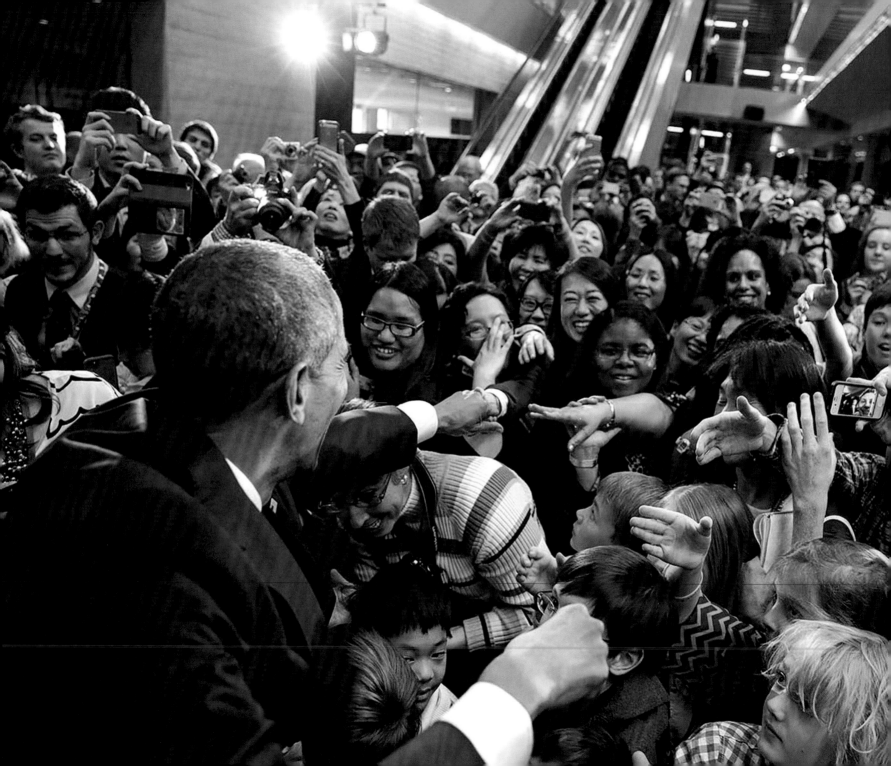

" WE GATHER BECAUSE **WE HAVE CHOSEN** HOPE OVER FEAR, **UNITY OF PURPOSE** OVER CONFLICT AND DISCORD. "

—Inaugural address, January 20, 2009

> **"** I SEE WHAT'S POSSIBLE WHEN WE RECOGNIZE THAT **WE ARE ONE AMERICAN FAMILY,** ALL DESERVING OF EQUAL TREATMENT. **"**

—Remarks at memorial services in Dallas, TX, July 12, 2016

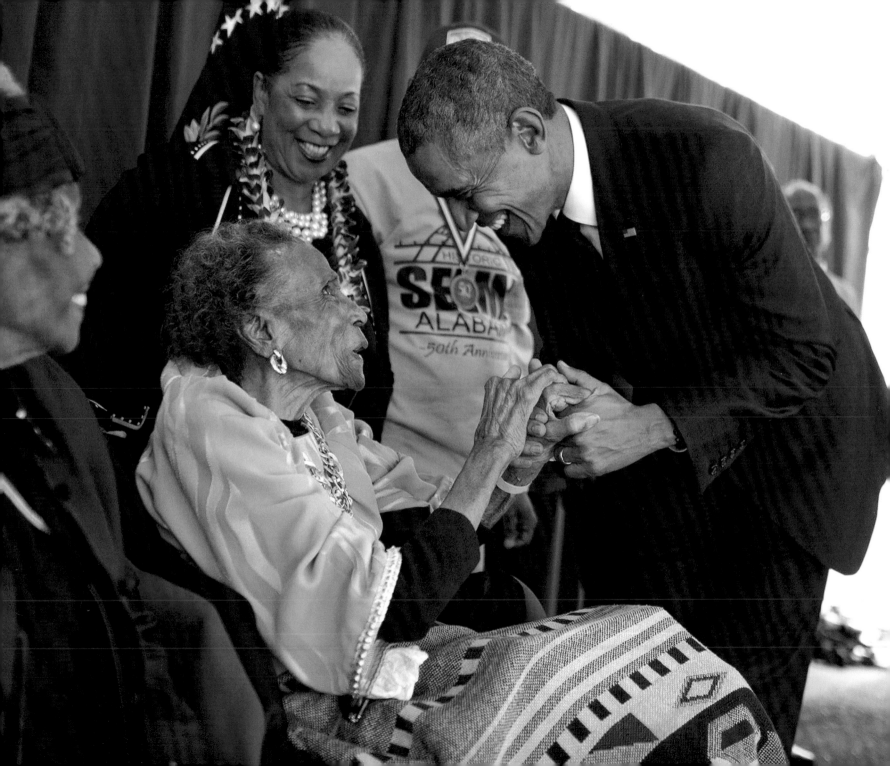

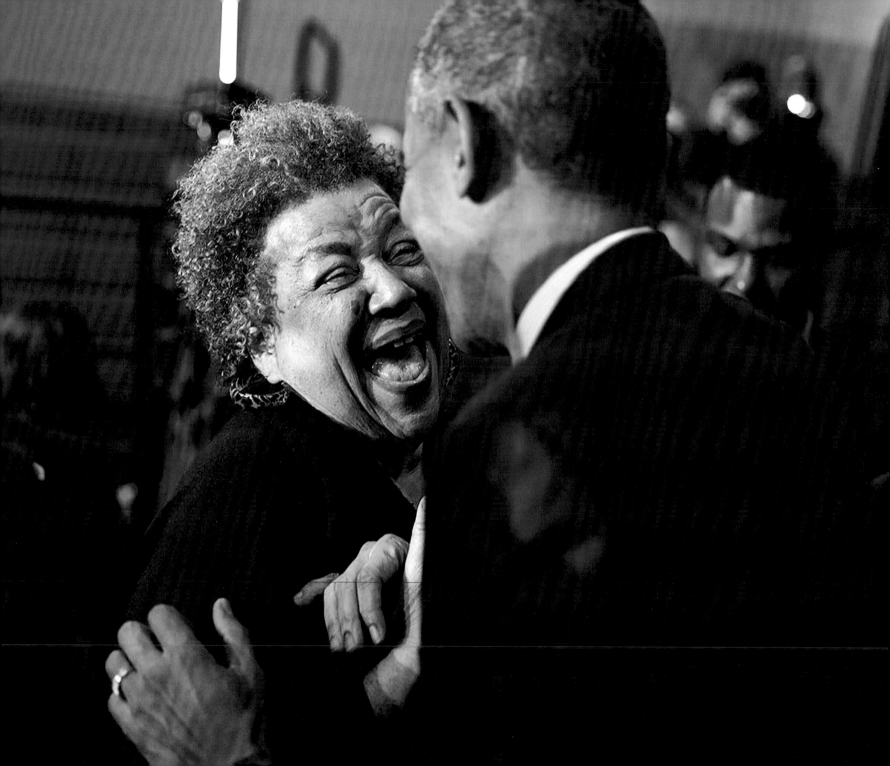

" ALL OF US SHARE THIS WORLD FOR BUT A BRIEF MOMENT IN TIME. The question is whether we spend that time focused on what pushes us apart, or whether we commit ourselves to an effort— a sustained effort—to find common ground... **"**

—Cairo University speech, June 4, 2009

FOR, IT TURNS OUT, WE DO NOT PERSEVERE ALONE.

Our character is not found in isolation.

HOPE

does not arise by putting
our fellow man down,

IT IS FOUND BY LIFTING OTHERS UP.

—Remarks at memorial services in Dallas, TX, July 12, 2016

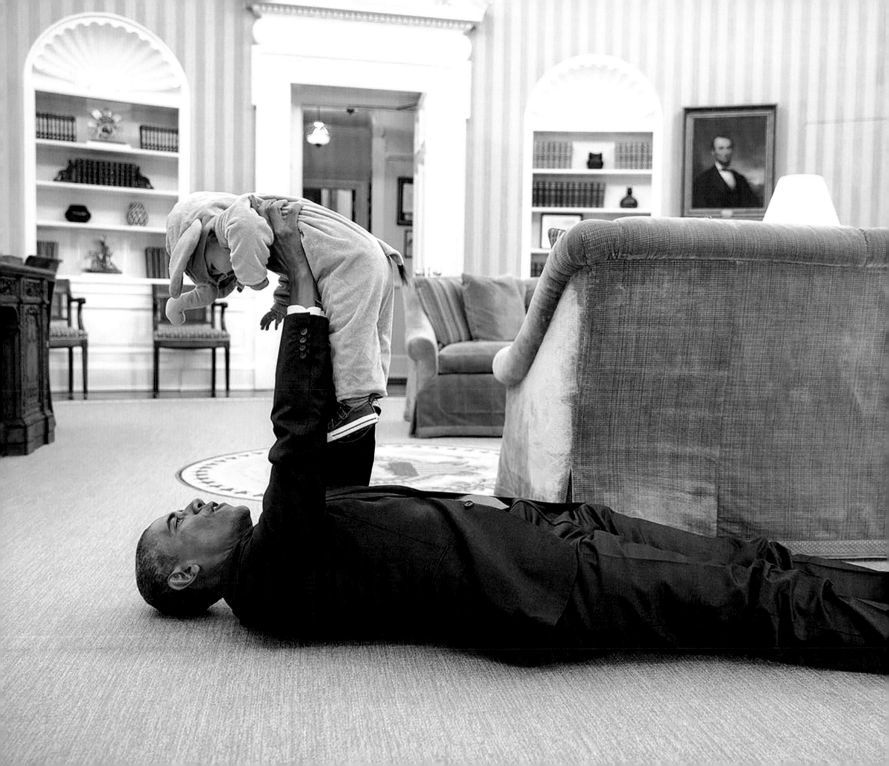

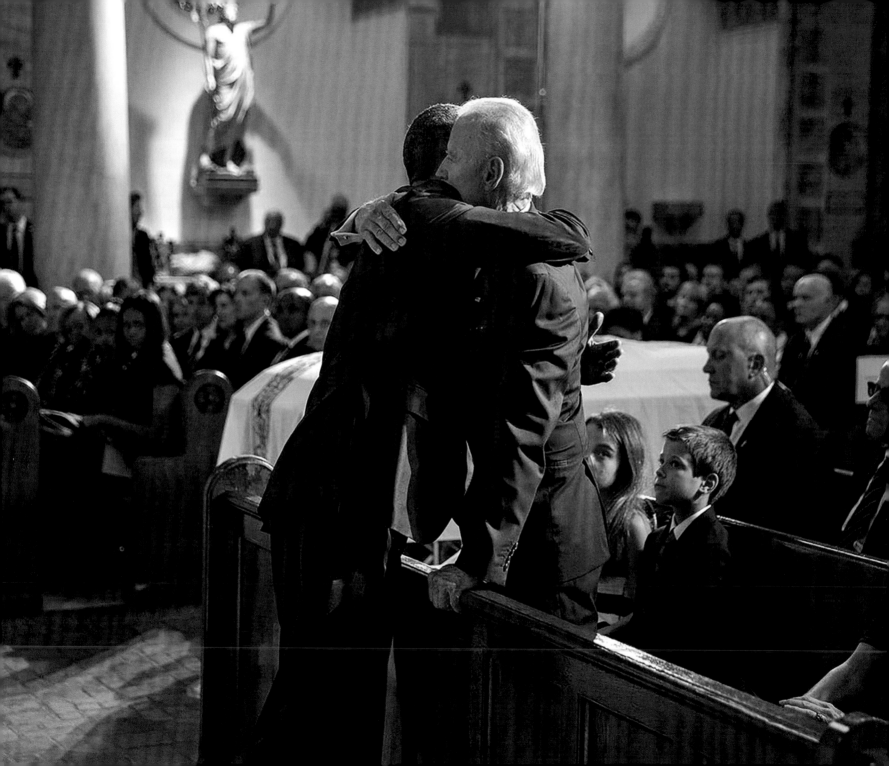

"I AM PRESIDENT, I AM NOT KING. I CAN'T DO THESE THINGS JUST BY MYSELF."

—Interview with *Univision*, October 25, 2010

"WE MAY NOT BE ABLE TO STOP ALL EVIL IN THE WORLD, BUT I KNOW THAT HOW WE TREAT ONE ANOTHER **IS ENTIRELY UP TO US.**"

—Remarks at memorial services in Tuscon, AZ, January 12, 2011

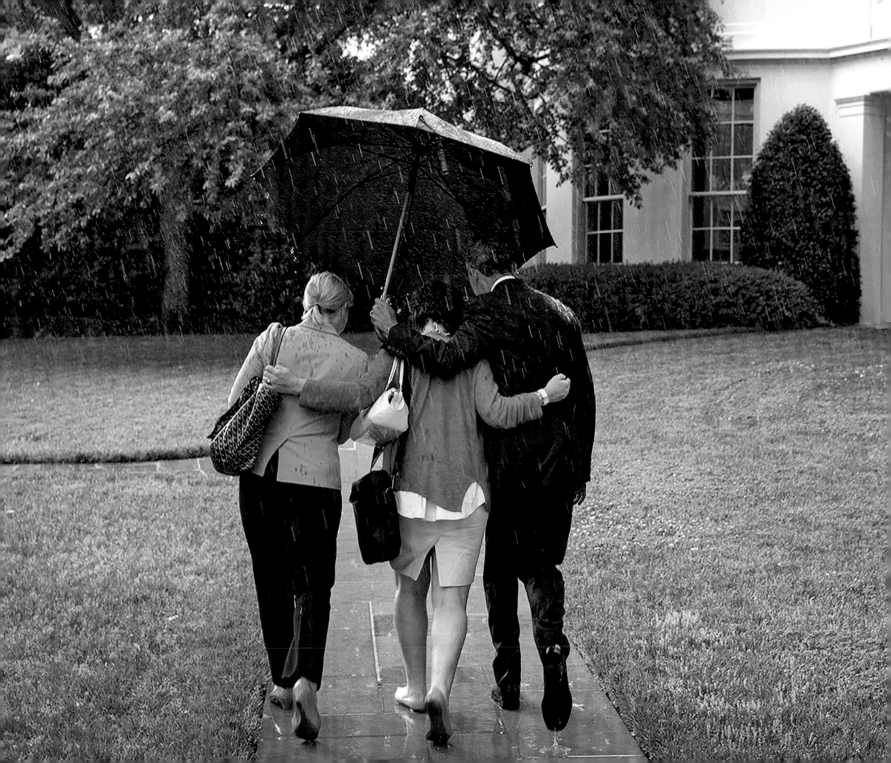

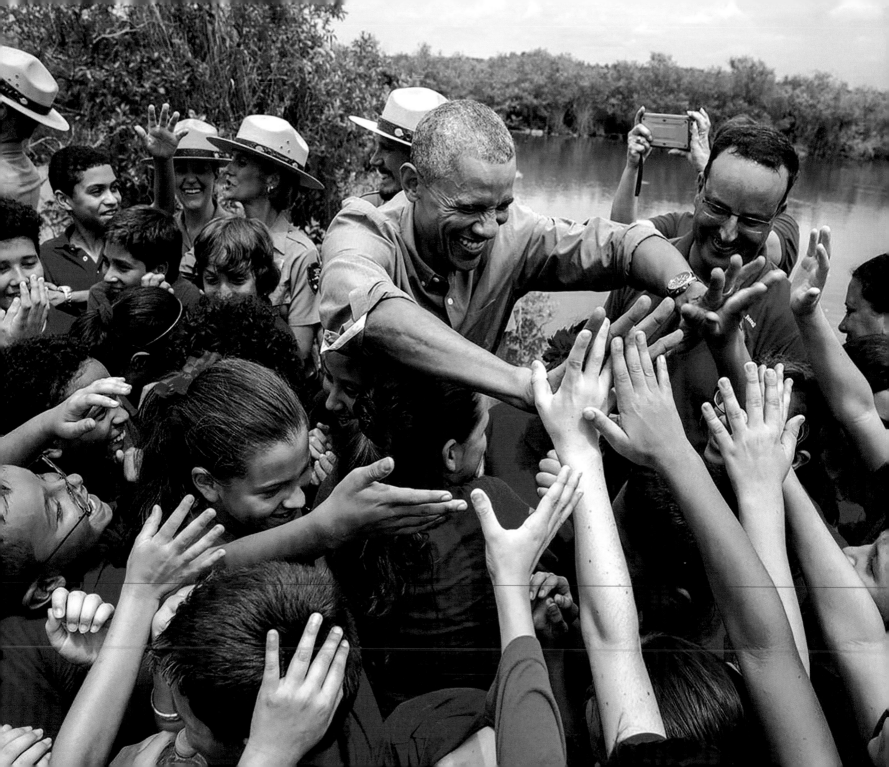

" OUR STORIES ARE SINGULAR, BUT OUR DESTINATION IS SHARED. "

—Presidential victory speech, November 5, 2008

"DISAGREEMENT **CANNOT MEAN** DYSFUNCTION. IT CAN'T DEGENERATE INTO **HATRED.**"

—Remarks at the White House, October 17, 2013

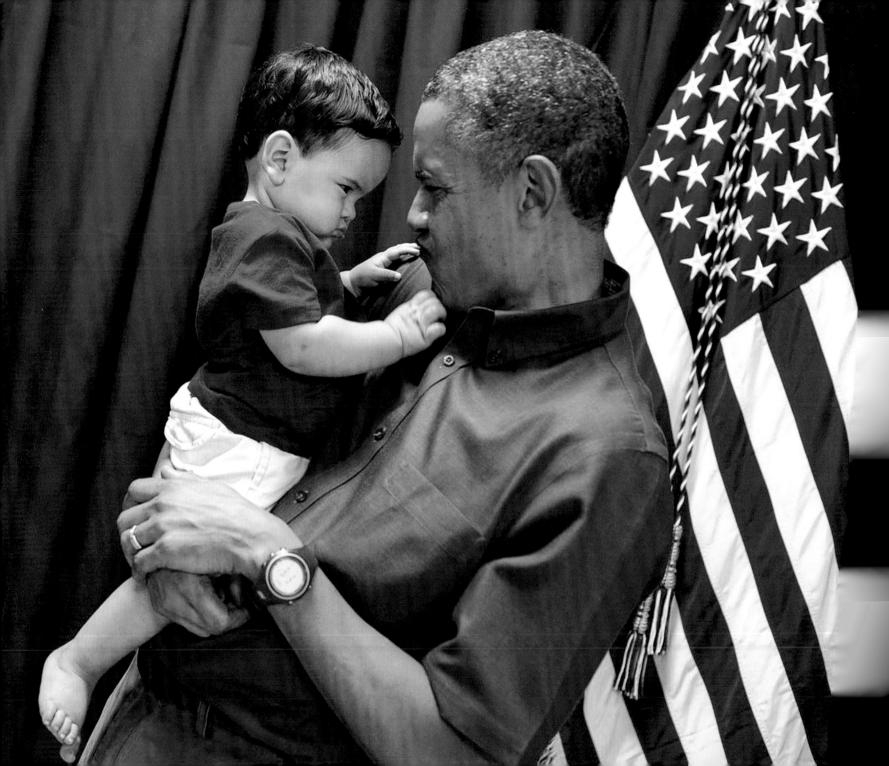

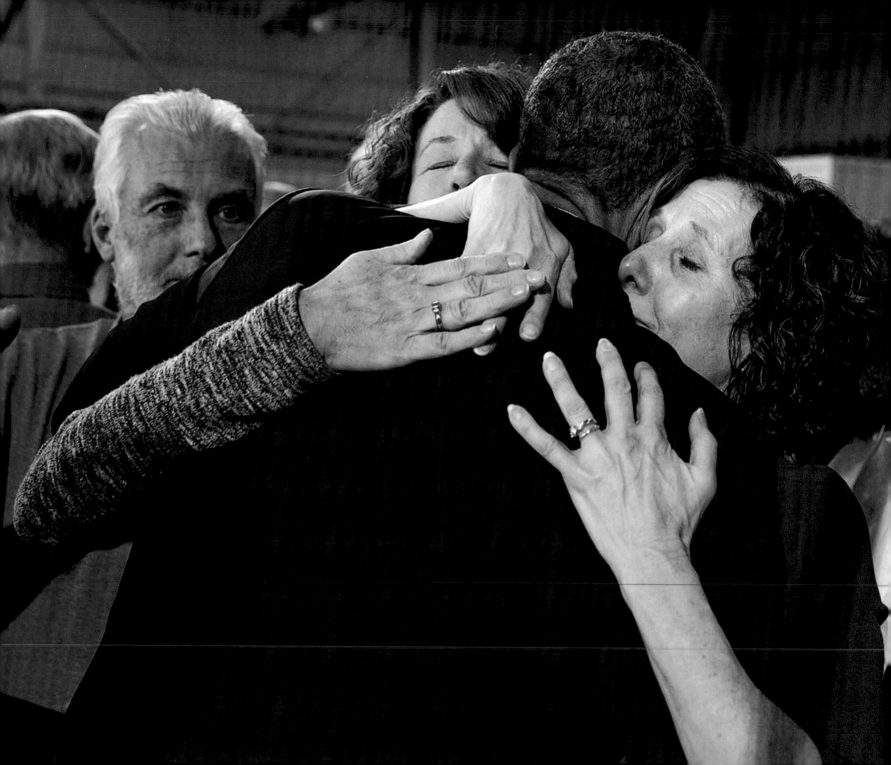

" Our founders quarreled and compromised, AND EXPECTED US TO DO THE SAME. But they knew that democracy does require A BASIC SENSE OF SOLIDARITY— the idea that for all our outward differences, **WE ARE ALL IN THIS TOGETHER;** THAT WE RISE OR FALL AS ONE. "

—Farewell address, January 10, 2017

" It's important for us to pause for a moment and make sure that we're talking with each other **IN A WAY THAT HEALS,** not in a way that wounds. "

—Remarks at memorial services in Tuscon, AZ, January 12, 2011

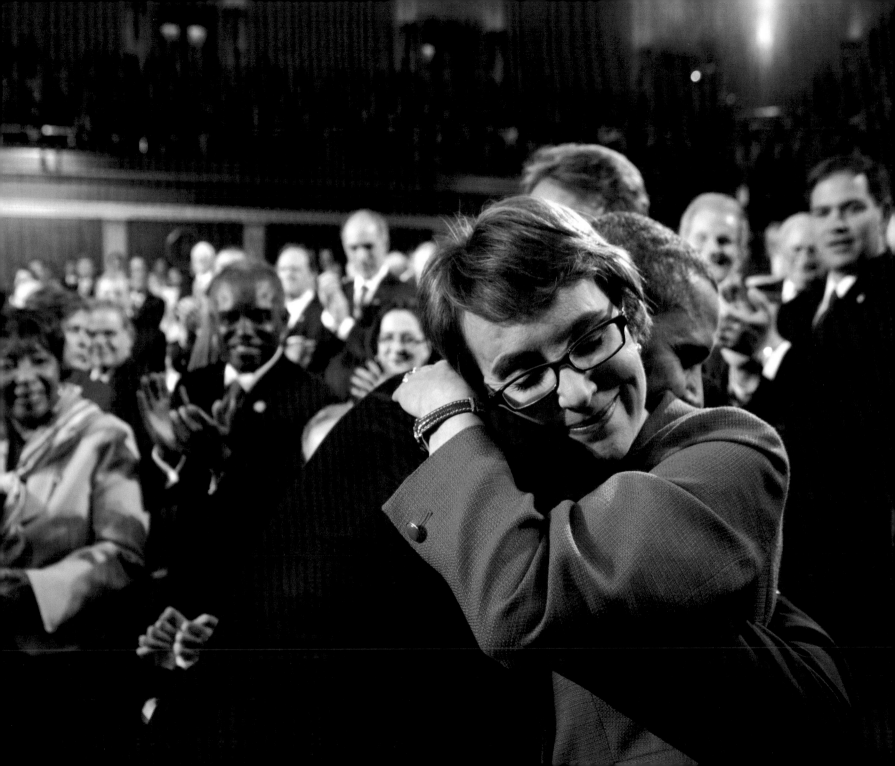

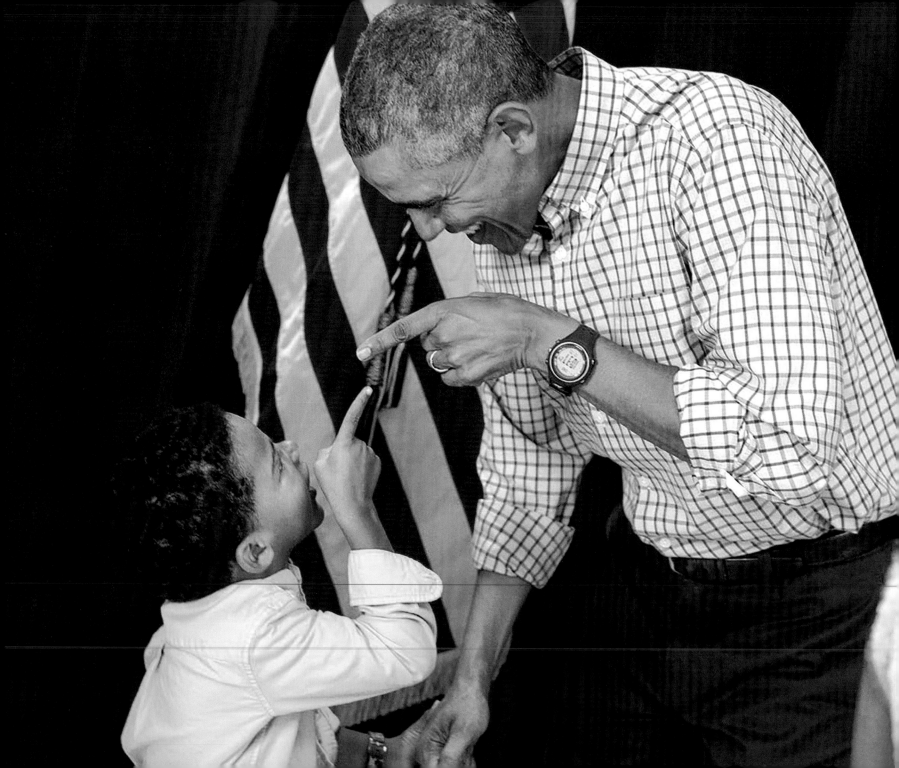

" And **IT IS YOU,** the young and fearless at heart, the most diverse and educated generation in our history, **WHO THE NATION IS WAITING TO FOLLOW.** "

—Remarks at the 50th Anniversary of the Selma to Montgomery Marches, March 7, 2015

"NEVER FORGET

THAT HONOR,
LIKE CHARACTER,
IS WHAT YOU DO WHEN
NOBODY IS LOOKING. "

—US Naval Academy commencement speech, May 24, 2013

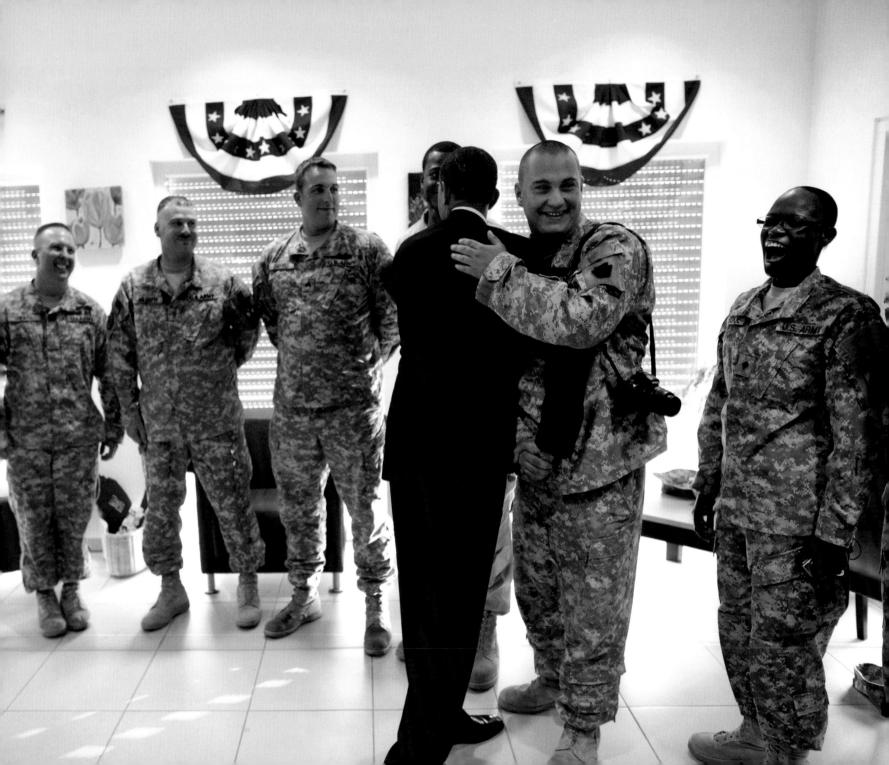

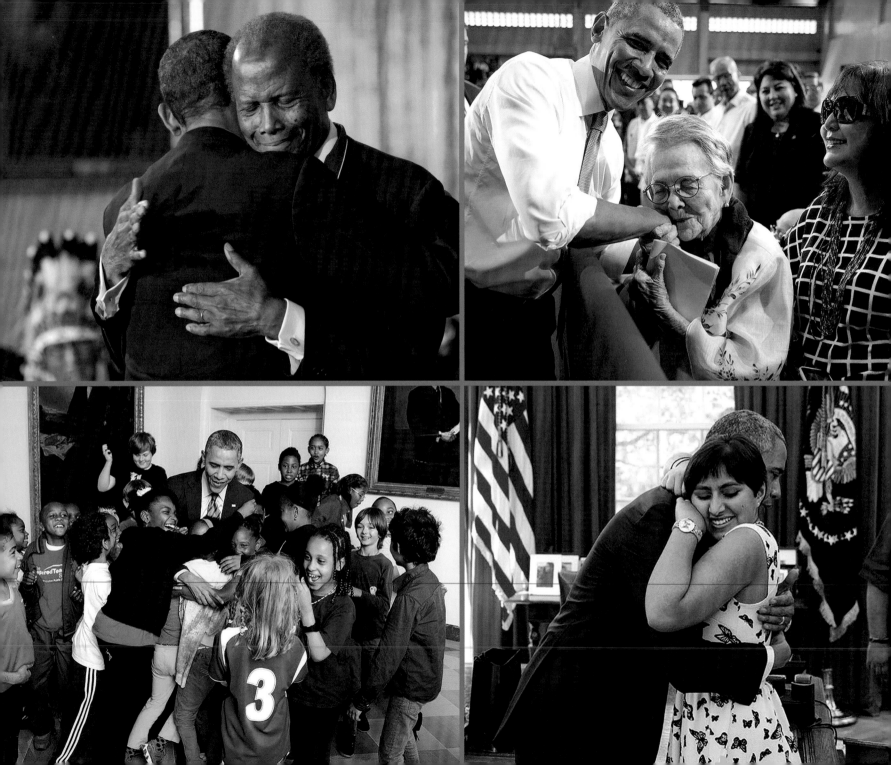

HOPE AND CHANGE

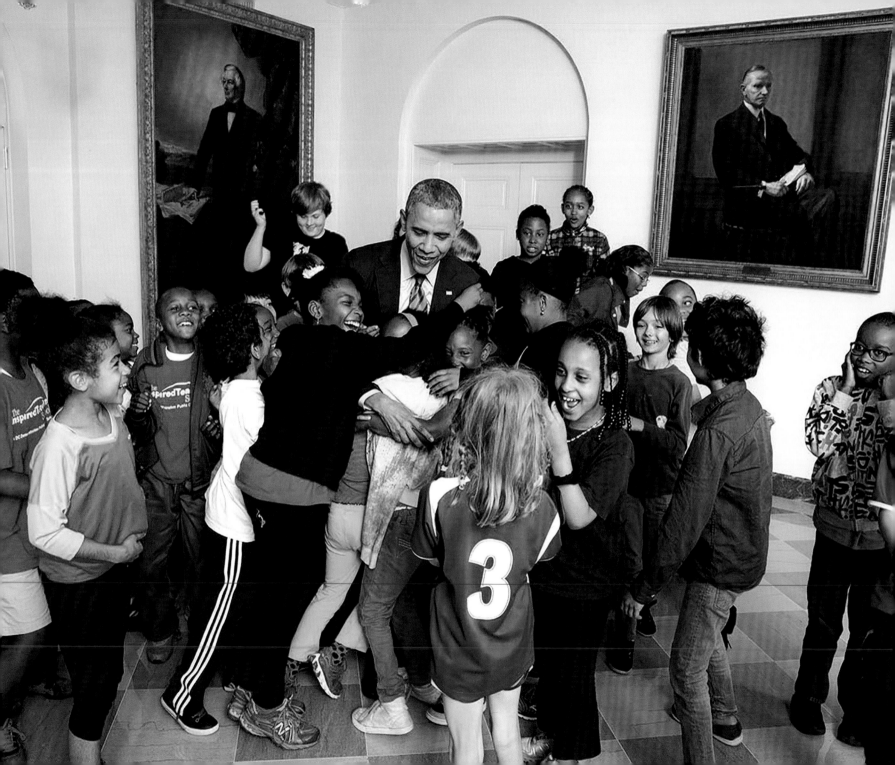

> Change will not come if we wait for some other person or some other time. **WE'RE THE ONES WE'VE BEEN WAITING FOR.** We are the change that we seek. "

—Super Tuesday speech, February 5, 2008

"WHILE WE BREATHE,
WE HOPE."

—Presidential victory speech, November 5, 2008

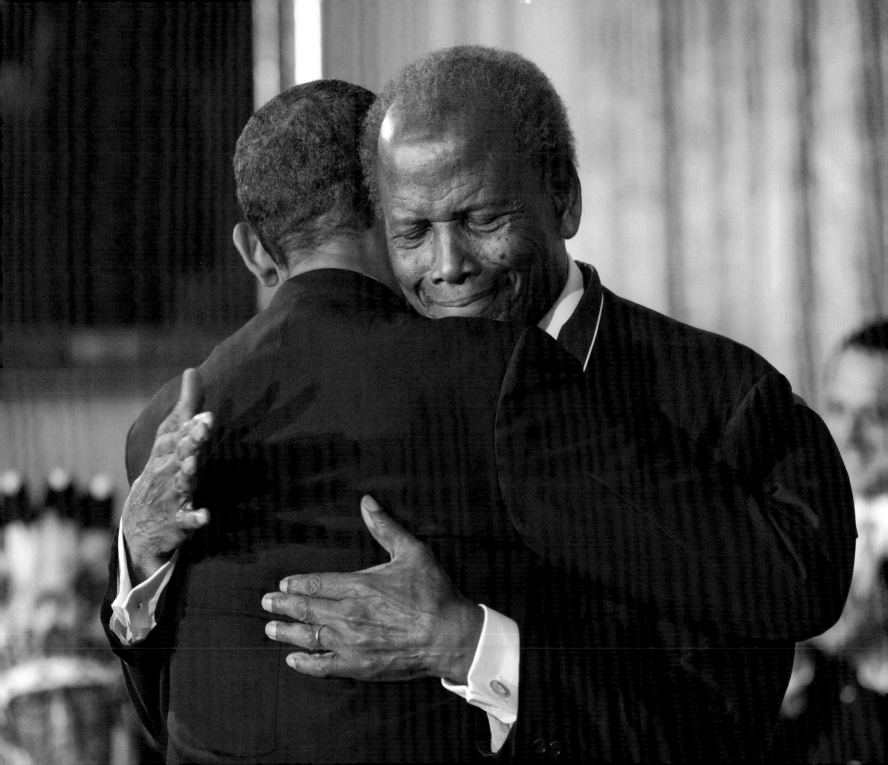

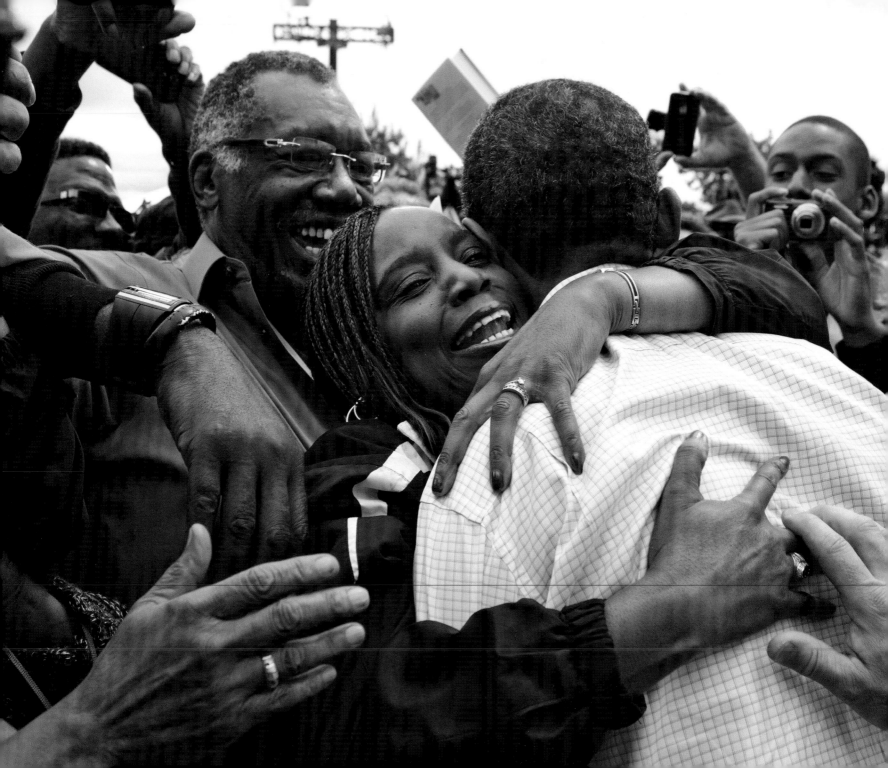

"CHANGE IS NEVER EASY, BUT ALWAYS POSSIBLE."

—NAACP Fight for Freedom Fund Dinner, May 1, 2005

"I HAVE ALWAYS BELIEVED

that hope is that stubborn thing inside us that insists, despite all the evidence to the contrary,

THAT SOMETHING BETTER AWAITS US

so long as we have the courage to keep reaching, to keep working, to keep fighting. "

—Presidential victory speech, November 6, 2012

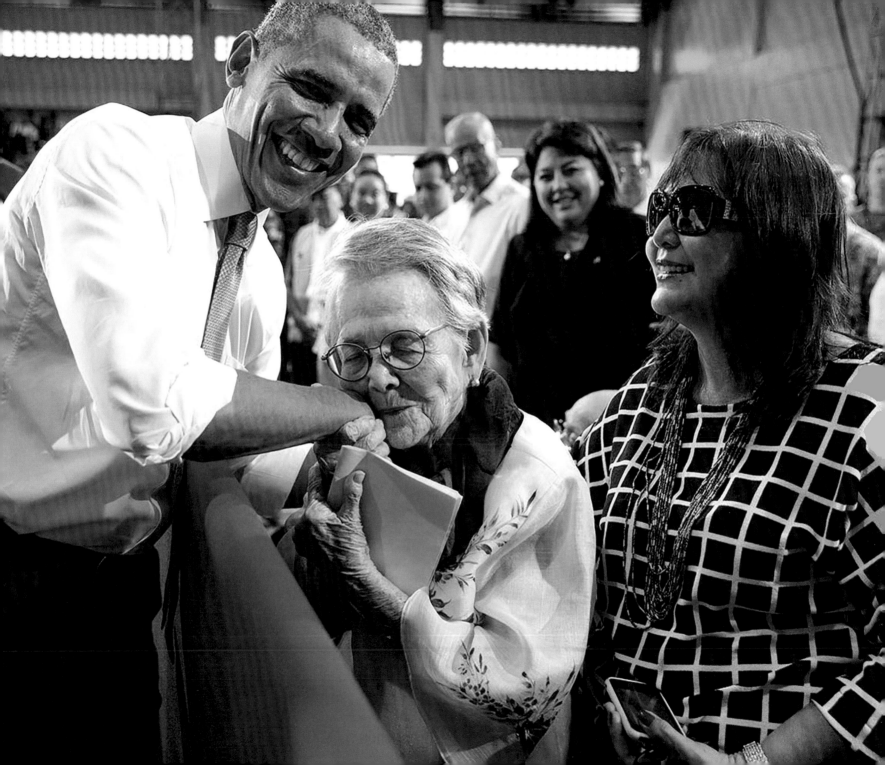

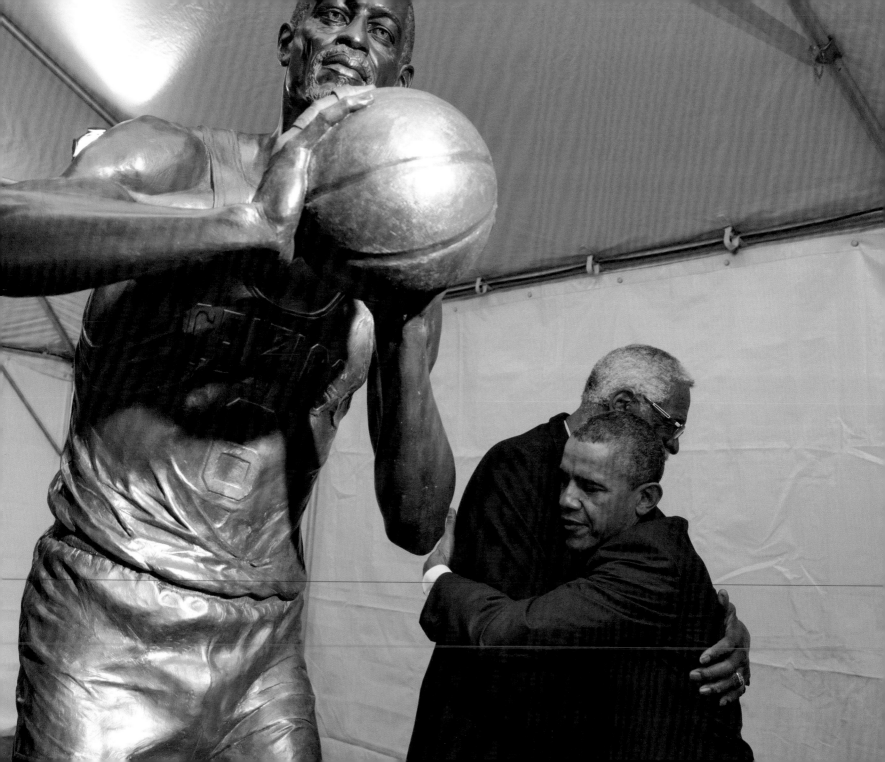

IF YOU HAVE A BAD GAME, you just move on. You look forward to the next one. And **IT MAKES YOU THAT MUCH MORE DETERMINED.**

—Post-debate interview with *ABC News*, October 10, 2012

"At the end of the day

WE'RE PART OF A LONG-RUNNING STORY.

We just try to get our paragraph right."

—"Going the Distance," *The New Yorker*, January 27, 2014

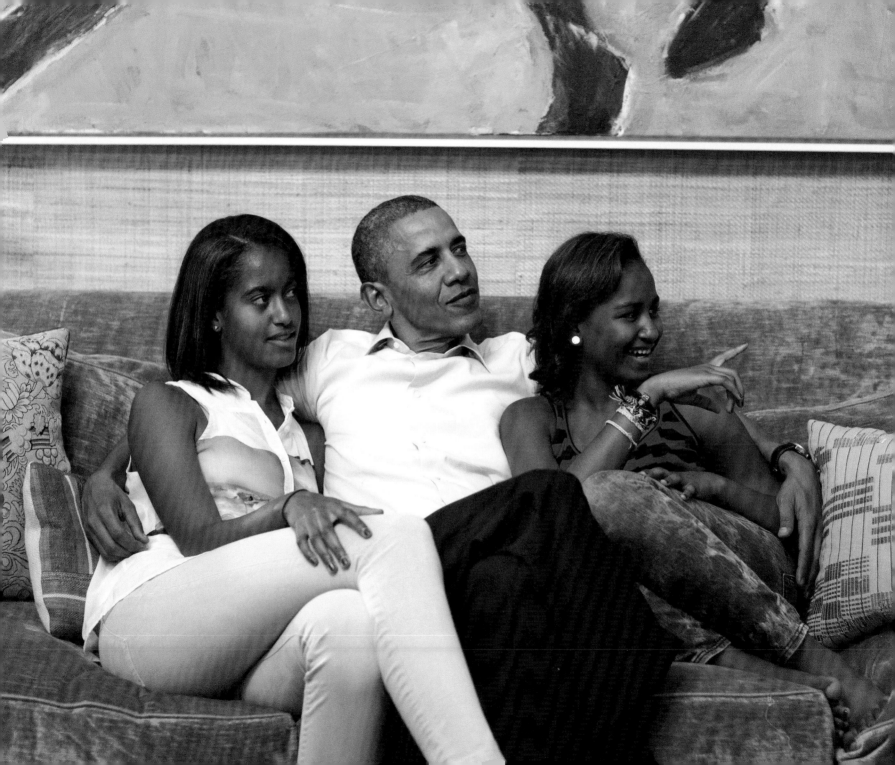

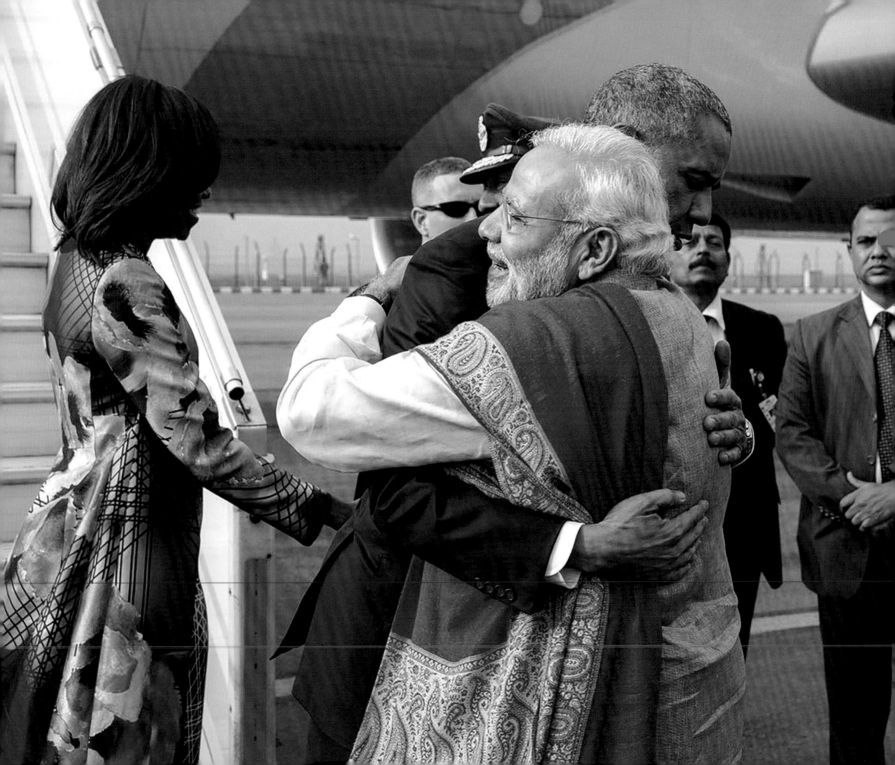

"As long as I **STAY FOCUSED** on those north stars, then I tend not to get too rattled."

—Interview with *HuffPost*, March 21, 2015

"AMERICA IS A PLACE WHERE YOU CAN **WRITE YOUR OWN DESTINY.**"

—Remarks on the Supreme Court decision on marriage equality, June 26, 2015

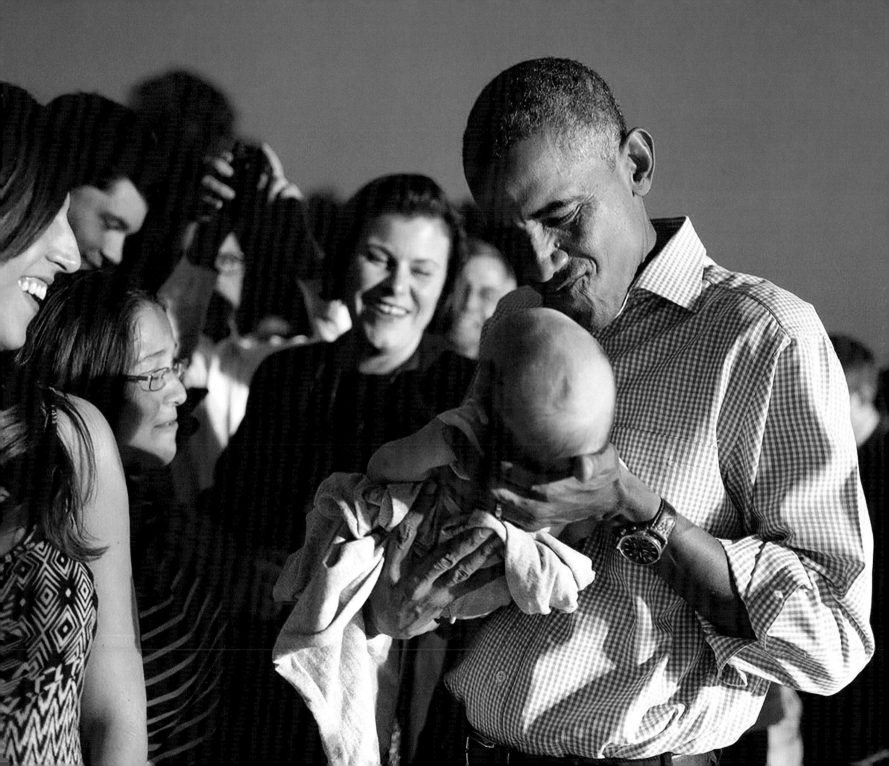

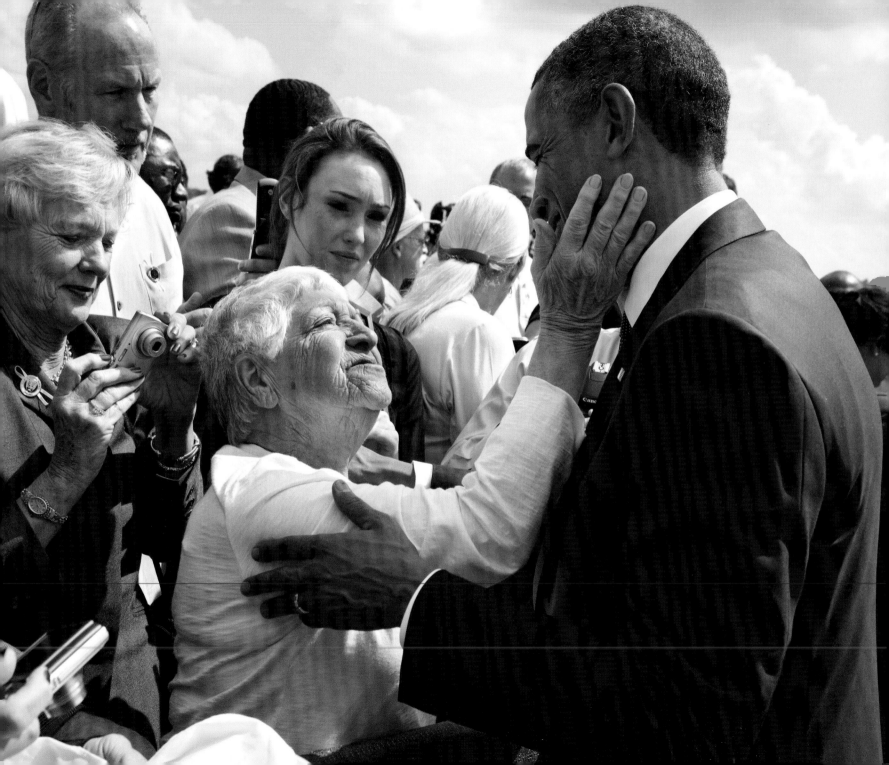

" It was on **THESE STREETS** where I witnessed the **POWER OF FAITH**, and the **QUIET DIGNITY** of working people in the face of struggle and loss. This is **WHERE I LEARNED** that **CHANGE ONLY HAPPENS WHEN ORDINARY PEOPLE** get involved, get engaged, and come together to **DEMAND IT.** "

—Farewell address, January 10, 2017

"WE CHOOSE HOPE OVER FEAR. **WE SEE THE FUTURE** NOT AS SOMETHING OUT OF OUR CONTROL, BUT **AS SOMETHING WE CAN SHAPE FOR THE BETTER** THROUGH CONCERTED AND COLLECTIVE EFFORT."

—United Nations General Assembly address, September 24, 2014

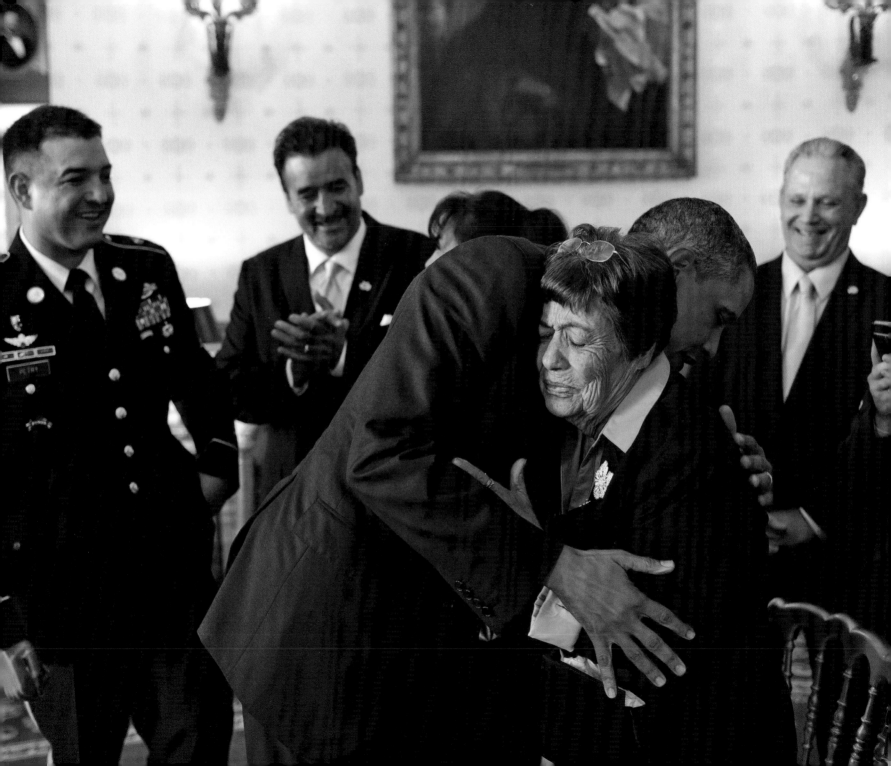

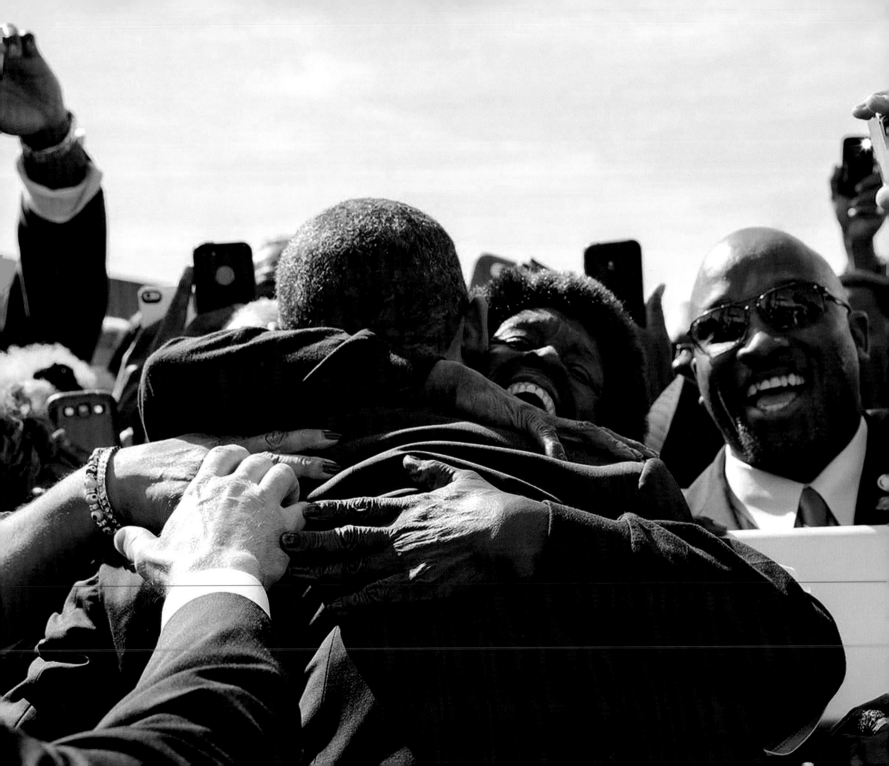

"THE FUTURE REWARDS THOSE **WHO PRESS ON.**"

—Remarks at the Congressional Black Caucus dinner, September 24, 2011

" Because for all our differences, **WE ARE ONE PEOPLE, STRONGER TOGETHER** than we could ever be alone. "

—Remarks on the Supreme Court decision on marriage equality, June 26, 2015

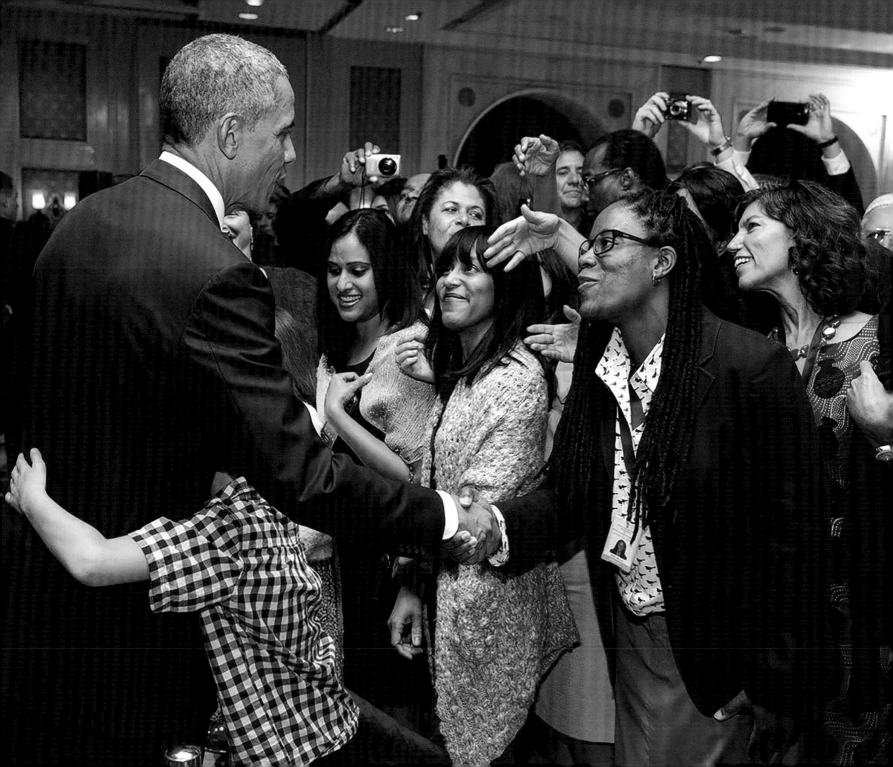

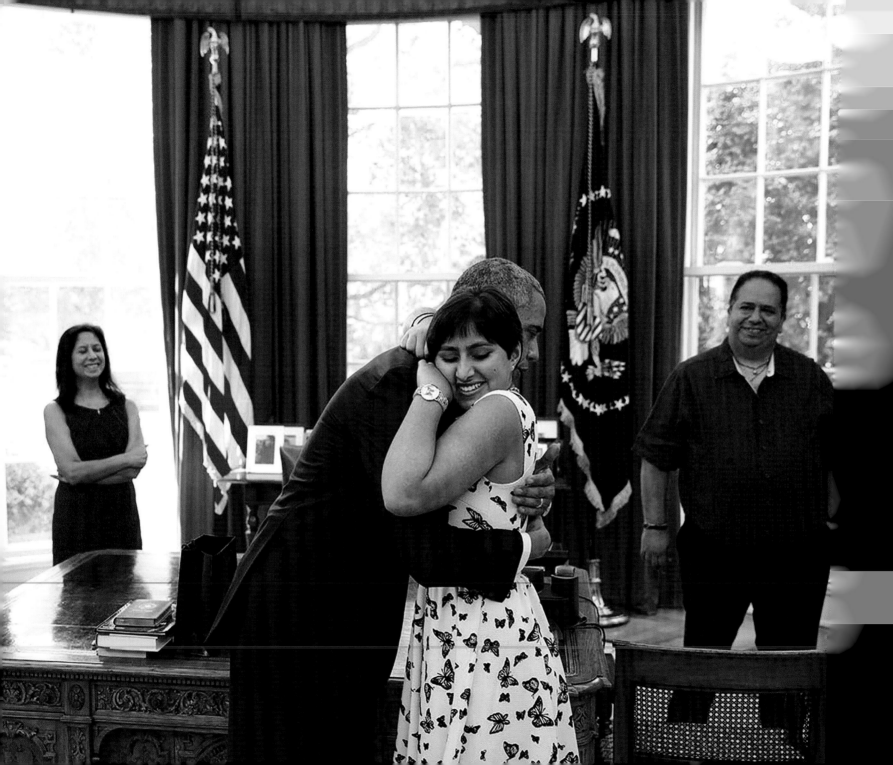

" In the face of impossible odds,

PEOPLE WHO LOVE THIS COUNTRY CAN CHANGE IT. "

—Iowa caucuses speech, January 3, 2008

"NOTHING CAN STAND IN THE WAY

of the power of millions of voices calling for change. "

—New Hampshire primary speech, January 8, 2008

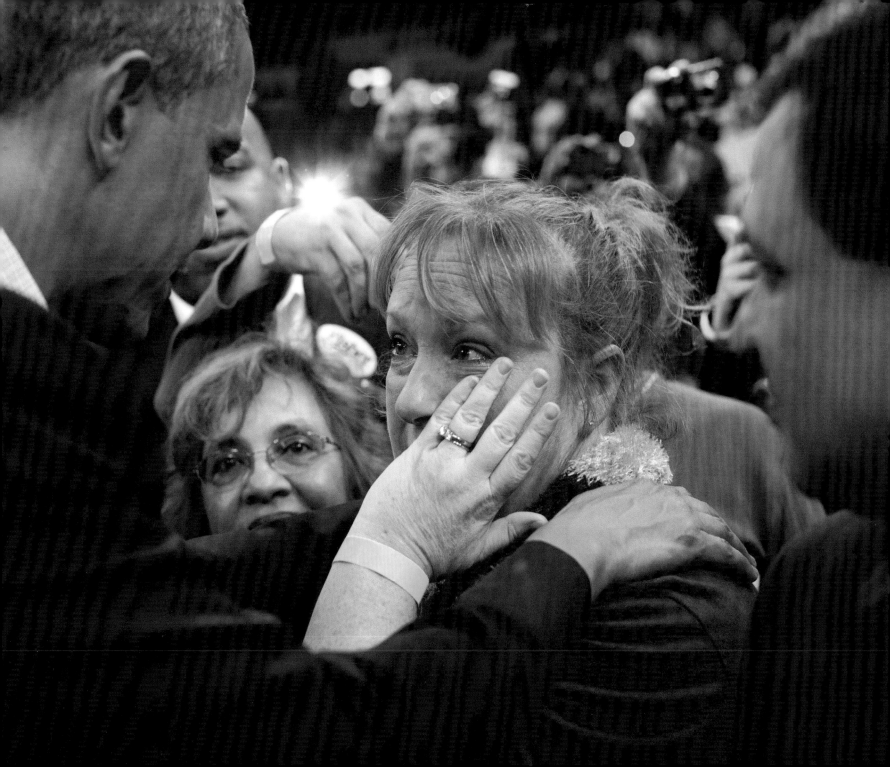

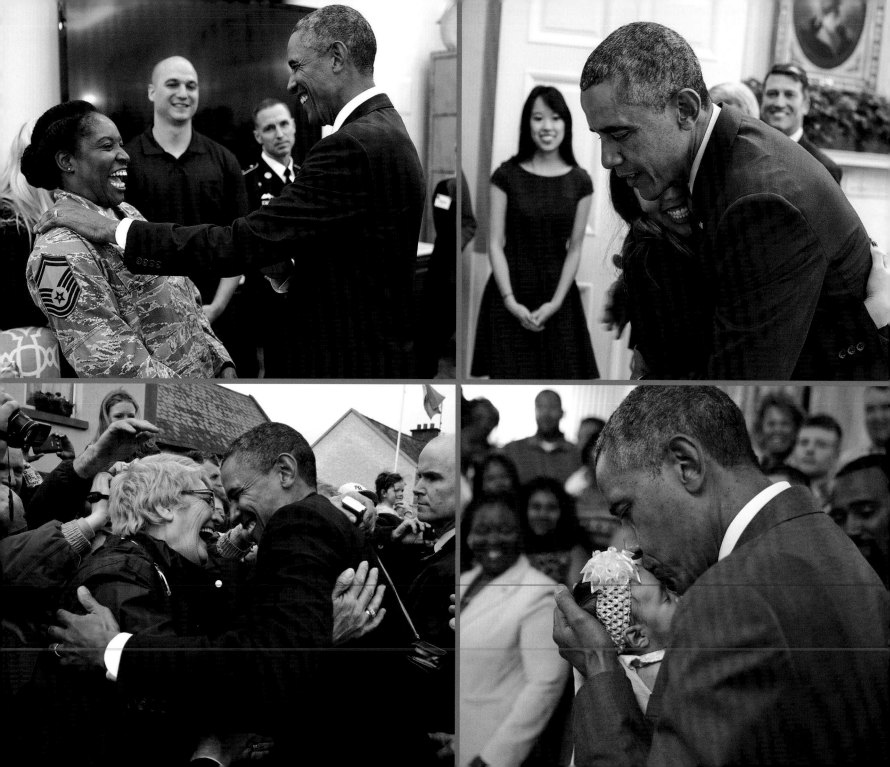

PROGRESS

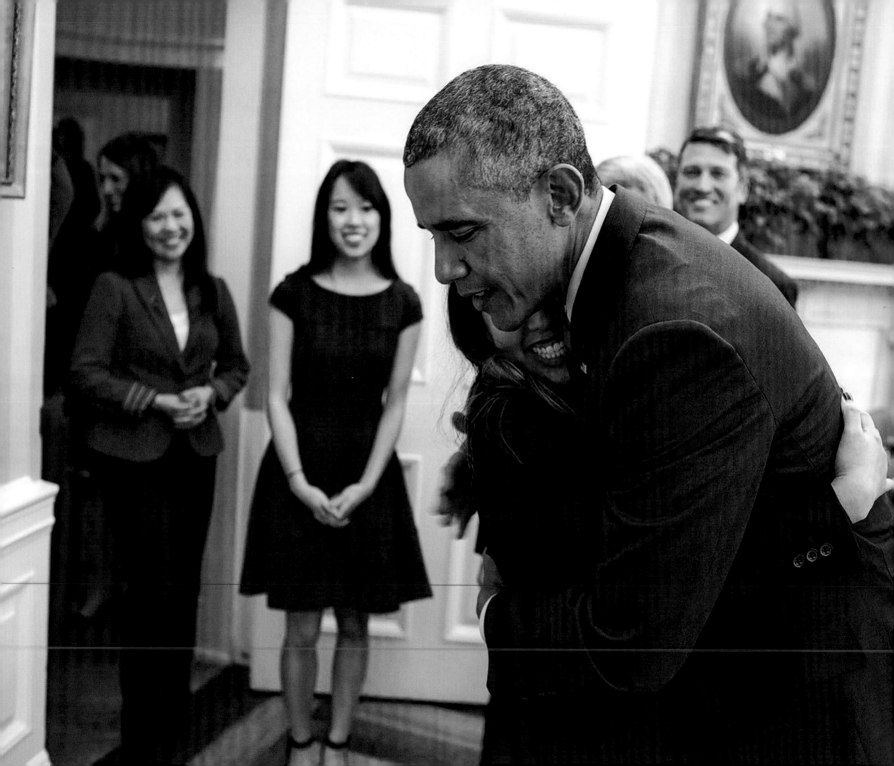

> " If you're walking down **THE RIGHT PATH** and you're willing to **KEEP WALKING**, eventually you'll **MAKE PROGRESS**. "

—Lincoln College commencement speech, 2005

"**PEOPLE**
don't progress
in a straight line.
COUNTRIES
don't progress
in a straight line."

—David Remnick's *The Bridge*, April 6, 2010

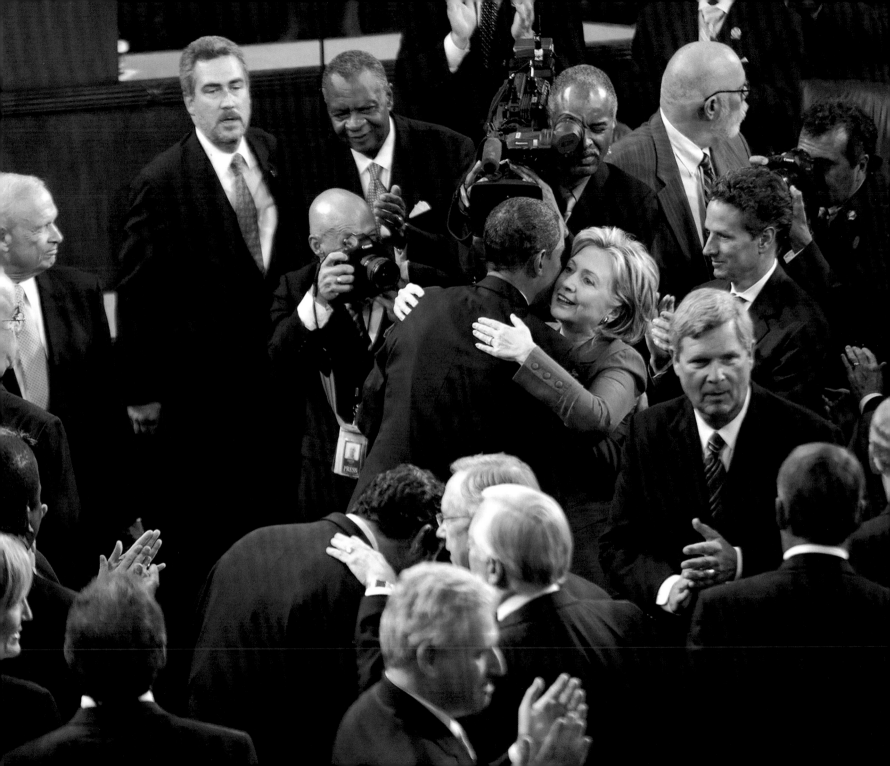

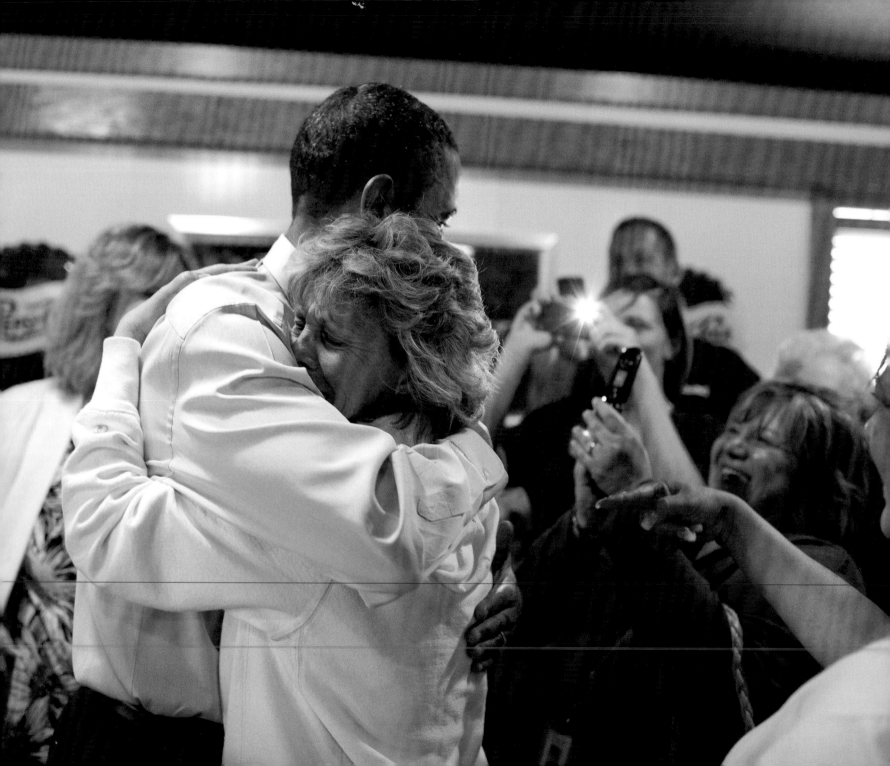

"WHERE YOU ARE RIGHT NOW DOESN'T HAVE TO DETERMINE WHERE YOU'LL END UP."

—Wakefield High School back-to-school speech, September 8, 2009

" WE MUST CARRY FORWARD the work of the women who came before us and ensure **OUR DAUGHTERS HAVE NO LIMITS ON THEIR DREAMS,** no obstacles to their achievements, and no remaining ceilings to shatter. **"**

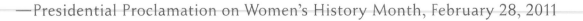

—Presidential Proclamation on Women's History Month, February 28, 2011

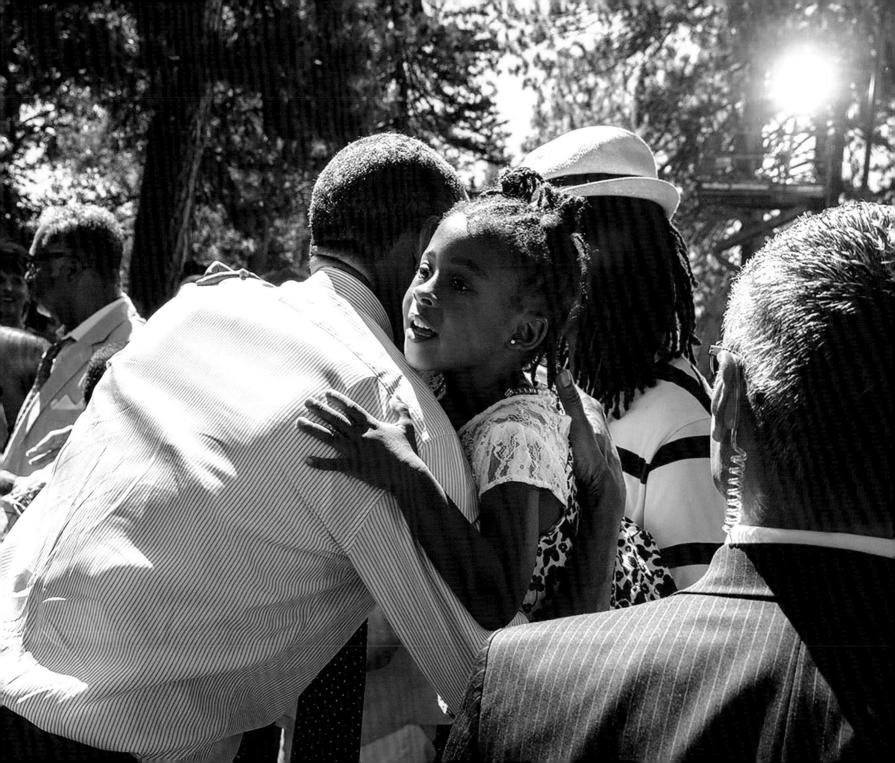

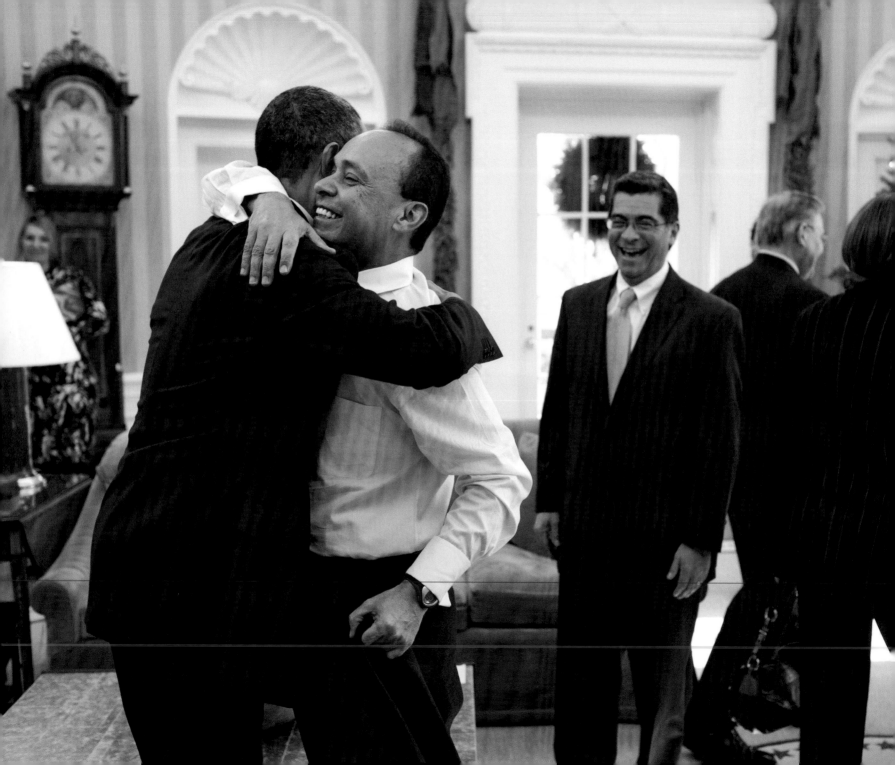

"OUR POLITICAL LIFE IS LIKE OUR INDIVIDUAL LIVES. THERE ARE UPS AND DOWNS. **THERE ARE PEAKS AND VALLEYS.**"

—Interview with *The New York Times Magazine*, October 12, 2010

" My attitude is,
if we're makin' progress,

**STEP BY STEP,
INCH BY INCH,
DAY BY DAY,**

that we are being true to
the spirit of that campaign. "

—Interview with *The Daily Show*, October 27, 2010

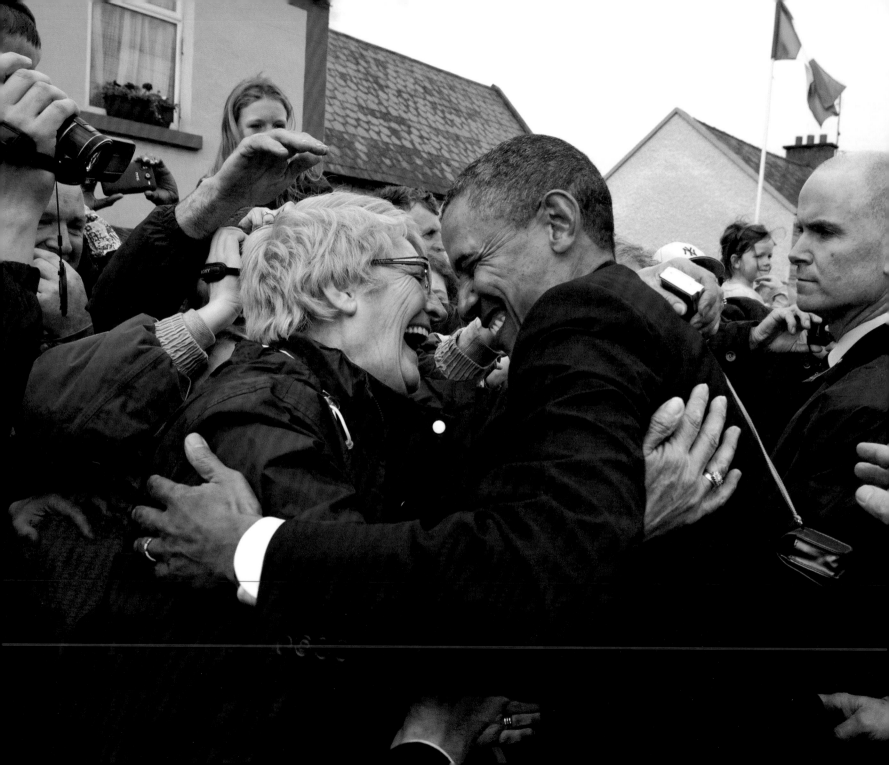

"I TRY TO FOCUS NOT ON THE FUMBLES, BUT ON THE NEXT PLAN."

—Interview with Bill O'Reilly, February 2, 2014

"YOU ARE STANDING IN A MOMENT WHERE **YOUR CAPACITY TO SHAPE THIS WORLD IS UNMATCHED.**"

—Town Hall speech with Young Leaders UK, April 23, 2016

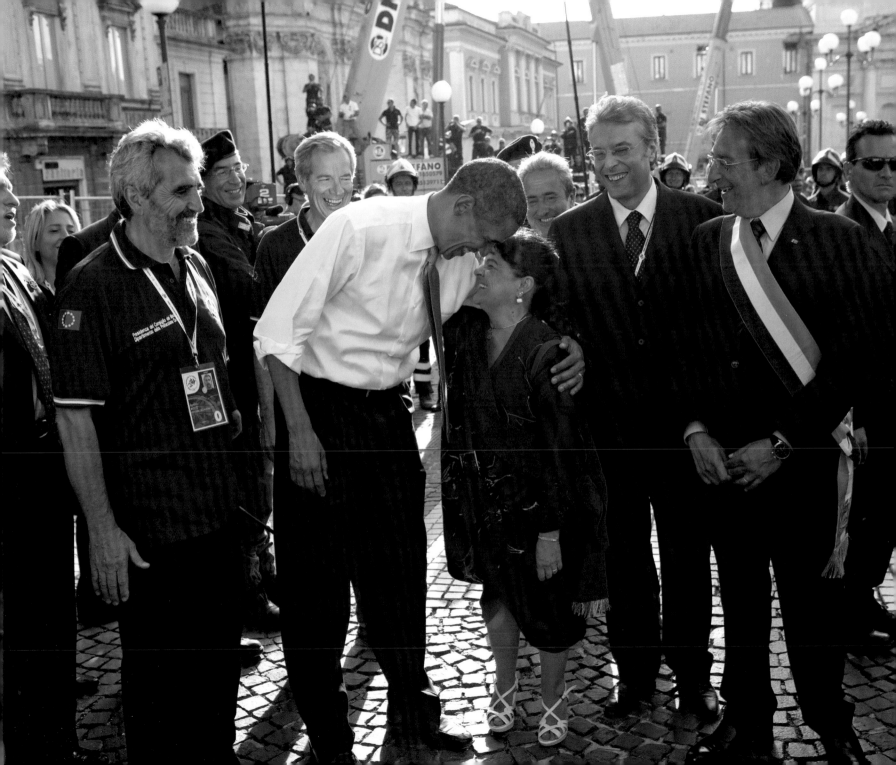

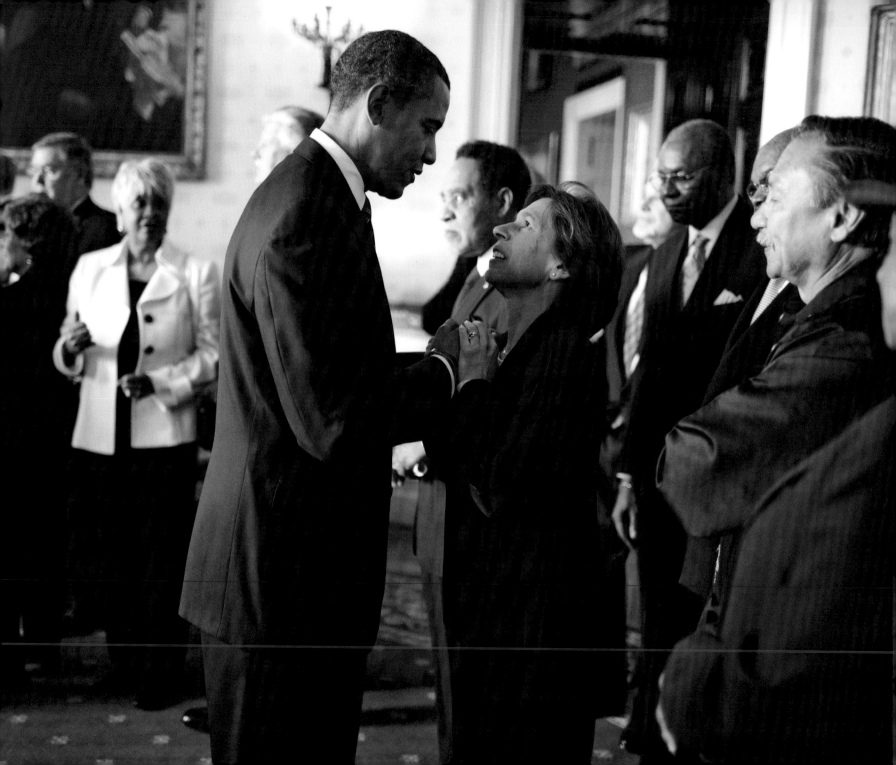

"PROGRESS WILL COME IN FITS AND STARTS. IT'S NOT ALWAYS A STRAIGHT LINE. IT'S NOT ALWAYS A SMOOTH PATH."

—Presidential victory speech, November 6, 2012

"IF YOU WORK HARD AND MEET YOUR RESPONSIBILITIES, YOU CAN GET AHEAD, NO MATTER WHERE YOU COME FROM, WHAT YOU LOOK LIKE, OR WHO YOU LOVE."

—State of the Union address, February 12, 2013

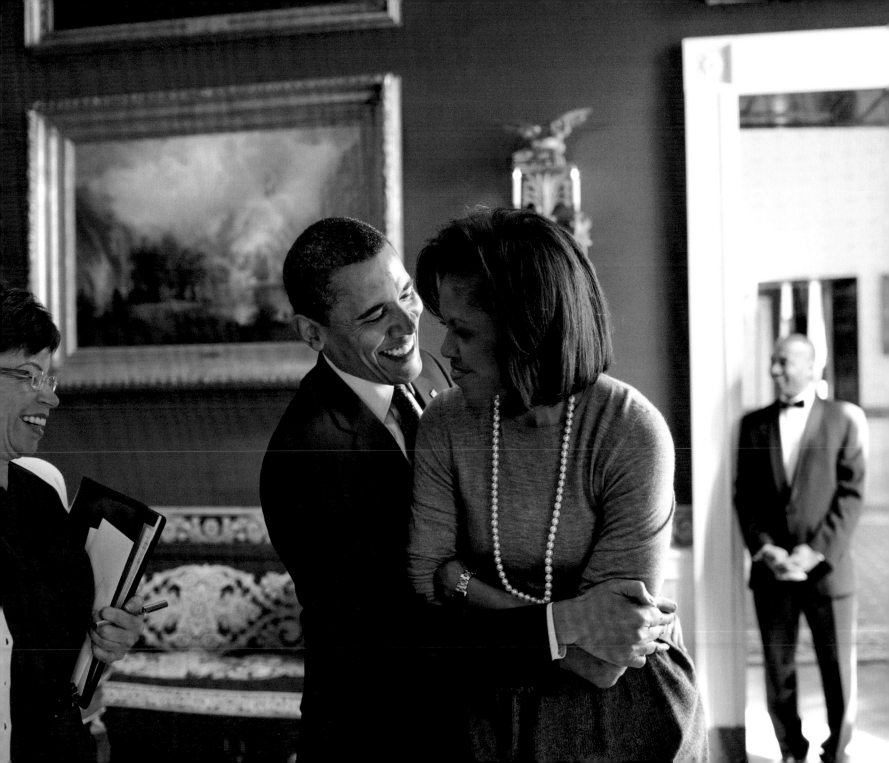

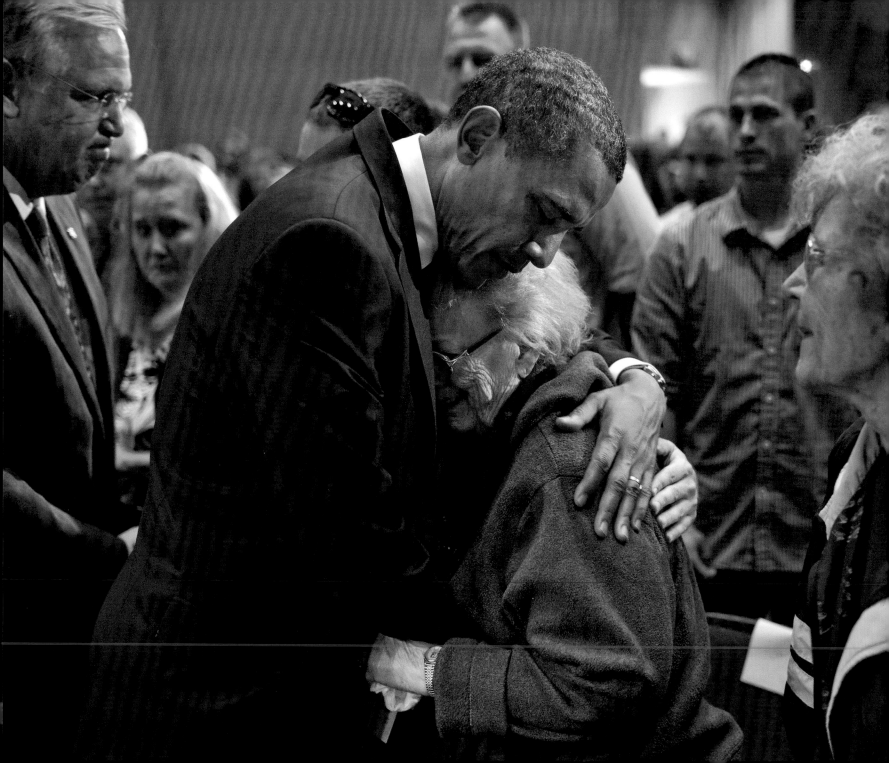

" SOMETIMES THERE ARE DAYS LIKE THIS, WHEN THAT SLOW, STEADY EFFORT IS REWARDED WITH JUSTICE THAT ARRIVES LIKE A THUNDERBOLT. "

—Remarks on the Supreme Court decision on marriage equality, June 26, 2015

"I BELIEVE IN CHANGE BECAUSE I **BELIEVE** IN YOU, THE AMERICAN PEOPLE."

—Final State of the Union address, January 12, 2016

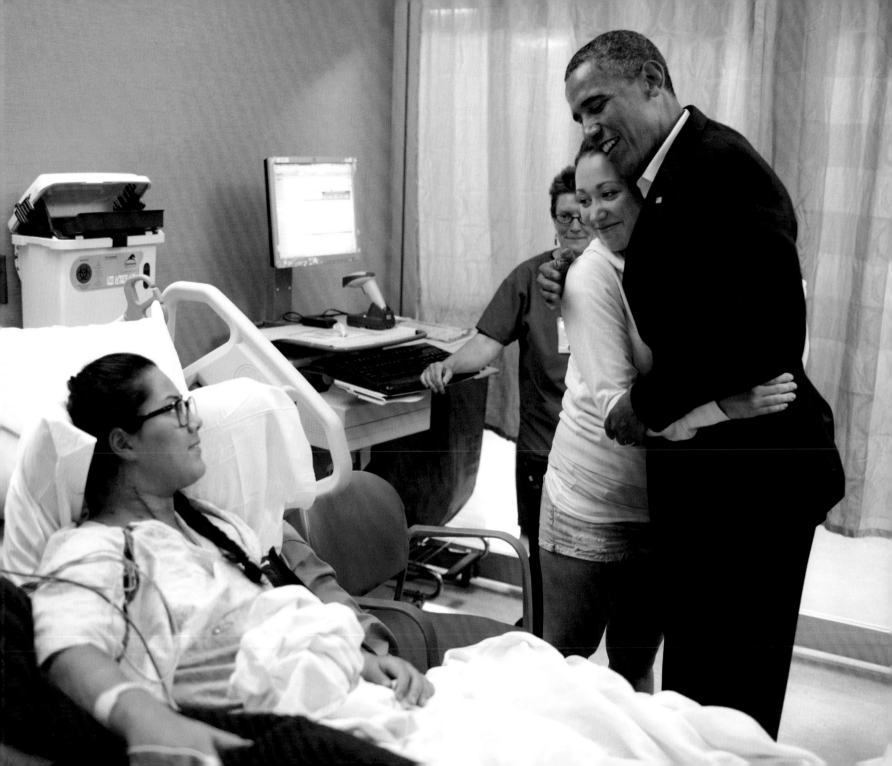

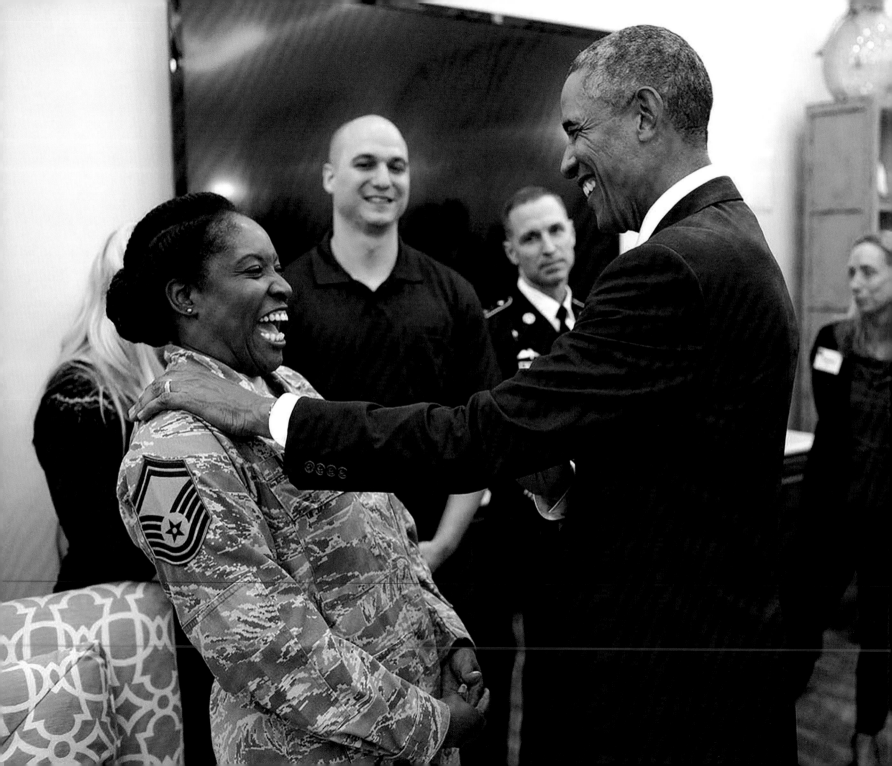

"My first piece of advice is this.

DON'T JUST GET INVOLVED.

Fight for your seat at the table.

Better yet: **FIGHT FOR A SEAT AT THE HEAD OF THE TABLE."**

—Barnard College commencement speech, May 14, 2012

" MY FELLOW AMERICANS,

it has been the honor of my life to serve you.

I won't stop; in fact, I will be right there with you,

as a citizen, for all my days that remain.

For now, whether you're young or young at heart,

I do have one final ask of you as your president. . . .

I AM ASKING YOU TO BELIEVE.

Not in my ability to bring about change —

BUT IN YOURS. **"**

—Farewell address, January 10, 2017

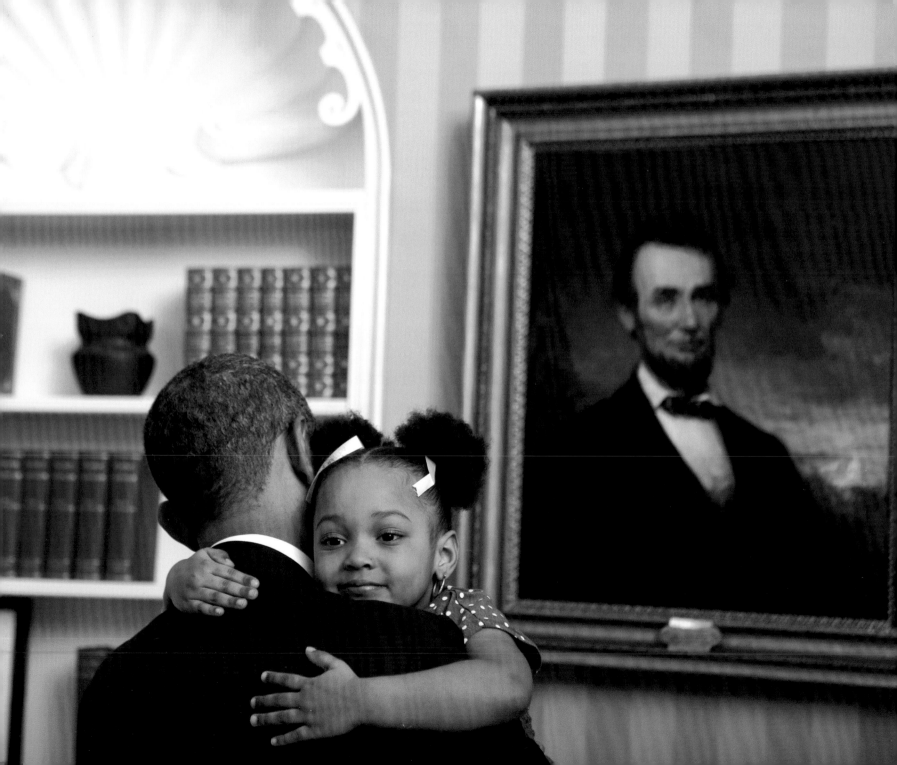

"YES WE CAN."

—Presidential campaign slogan, 2008